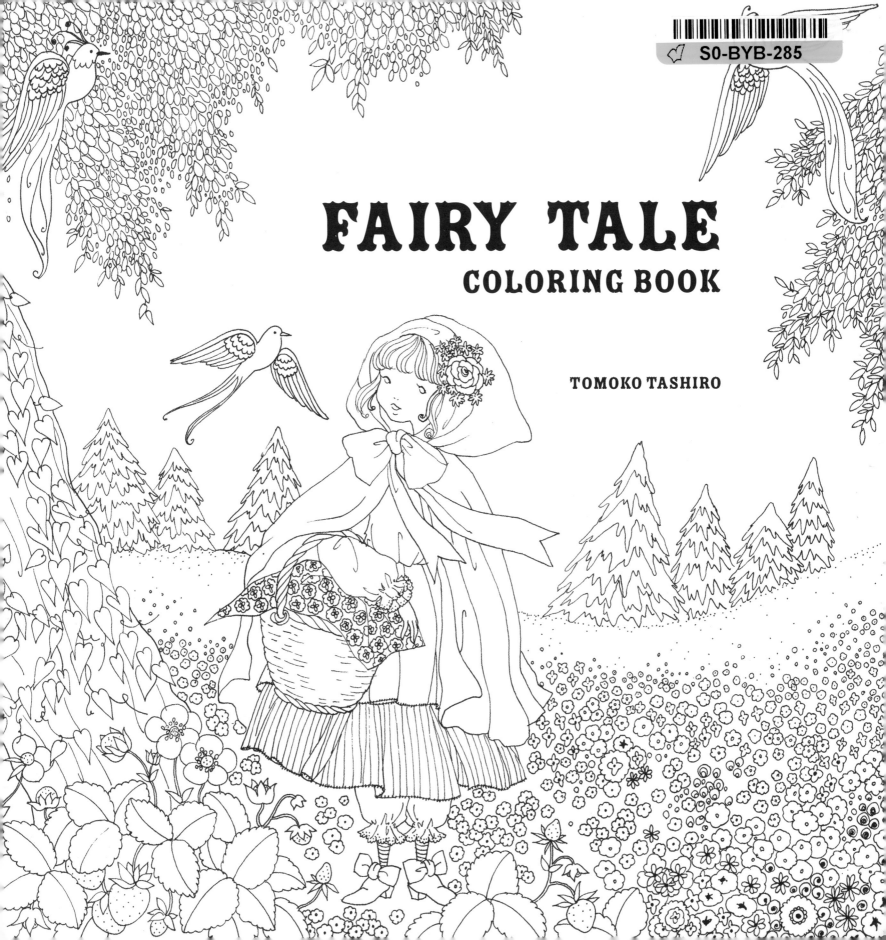

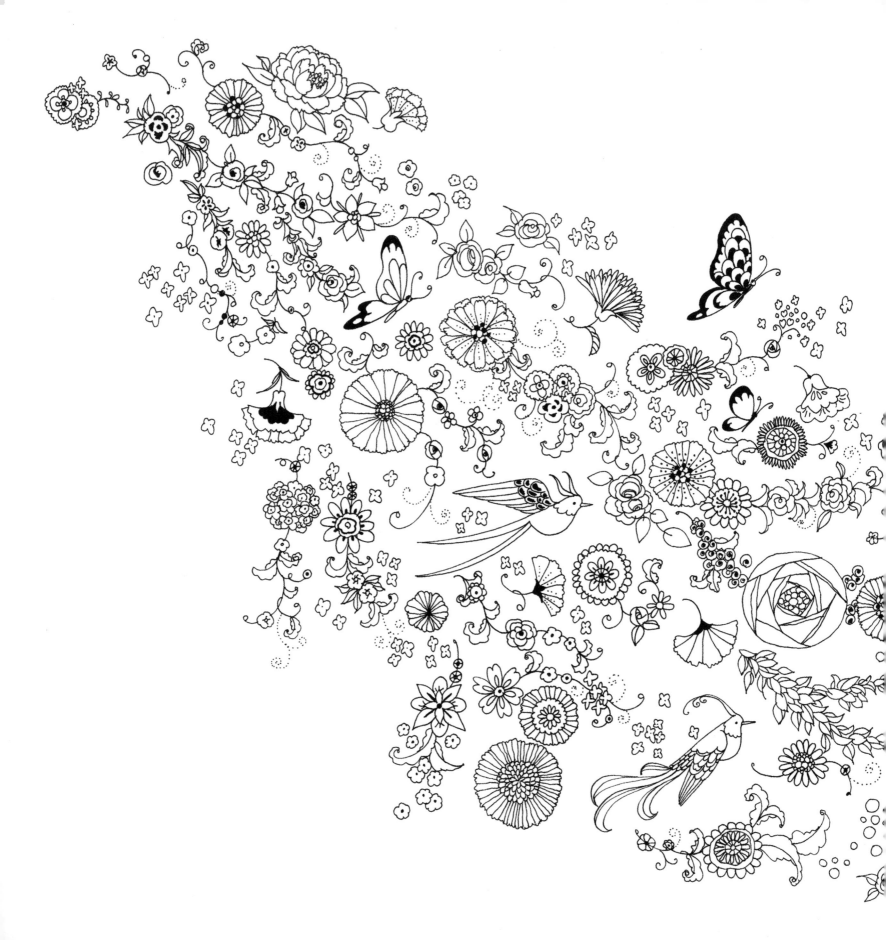

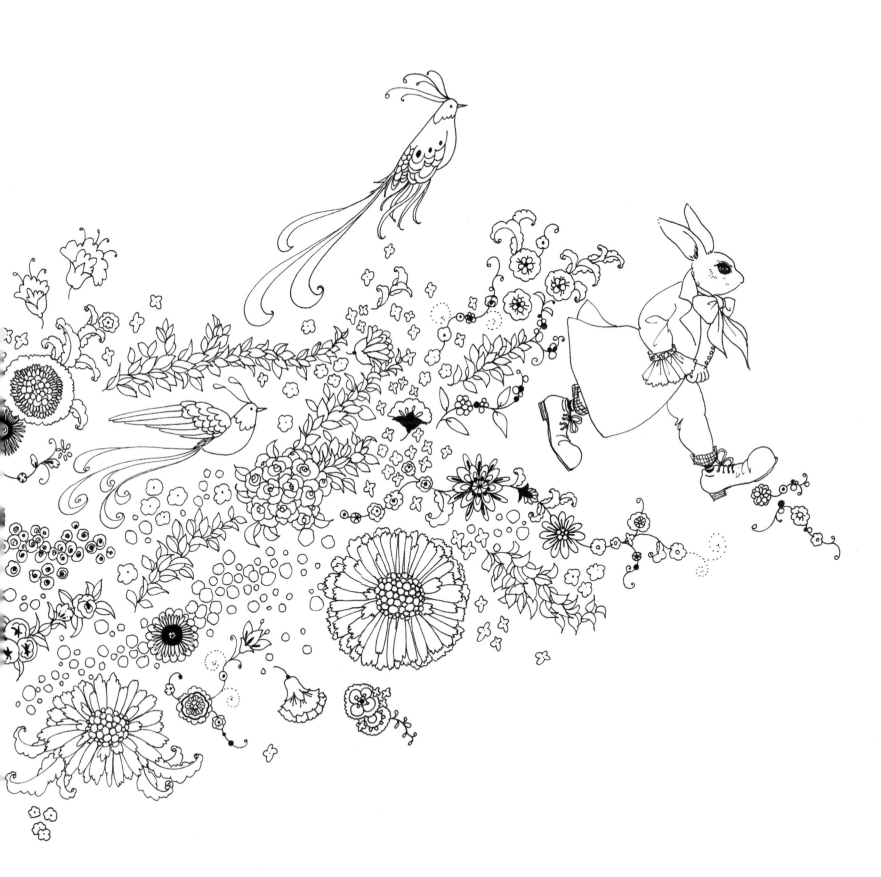

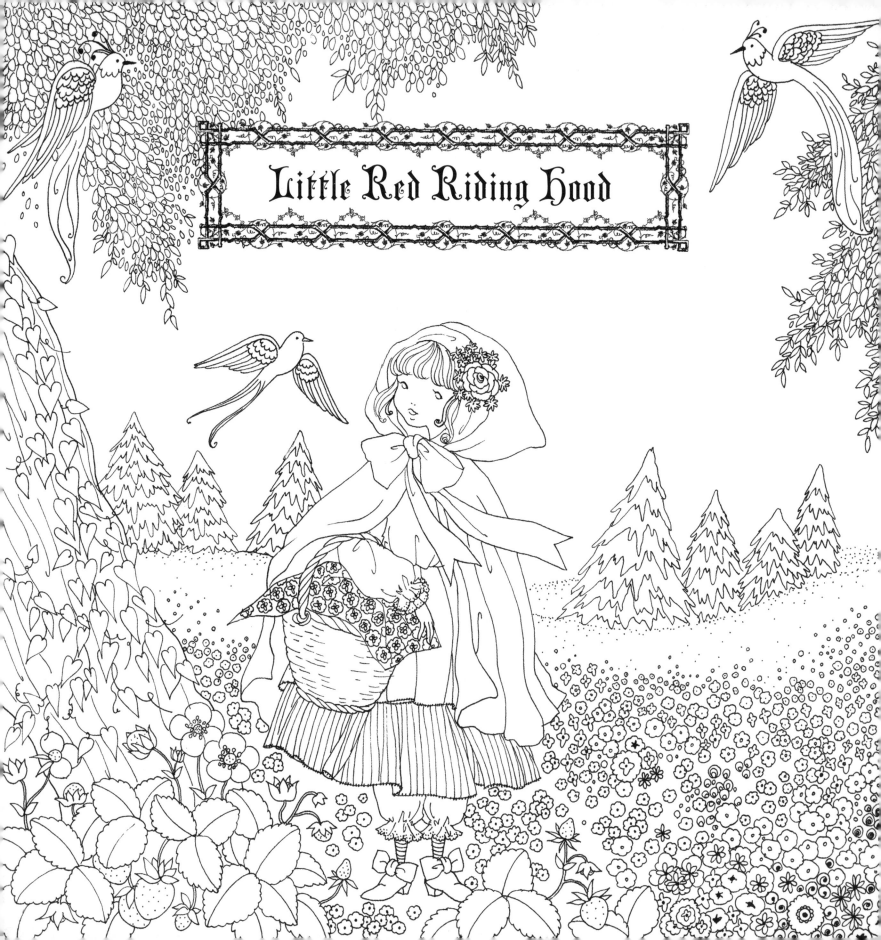

Little Red Riding Hood

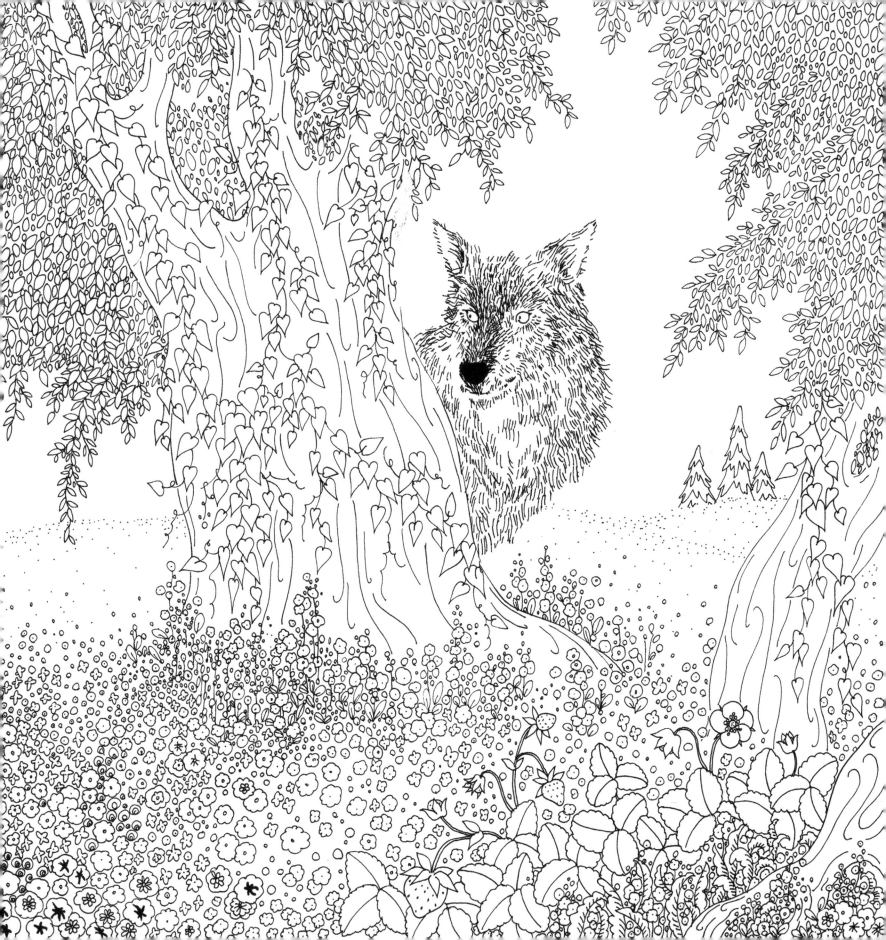

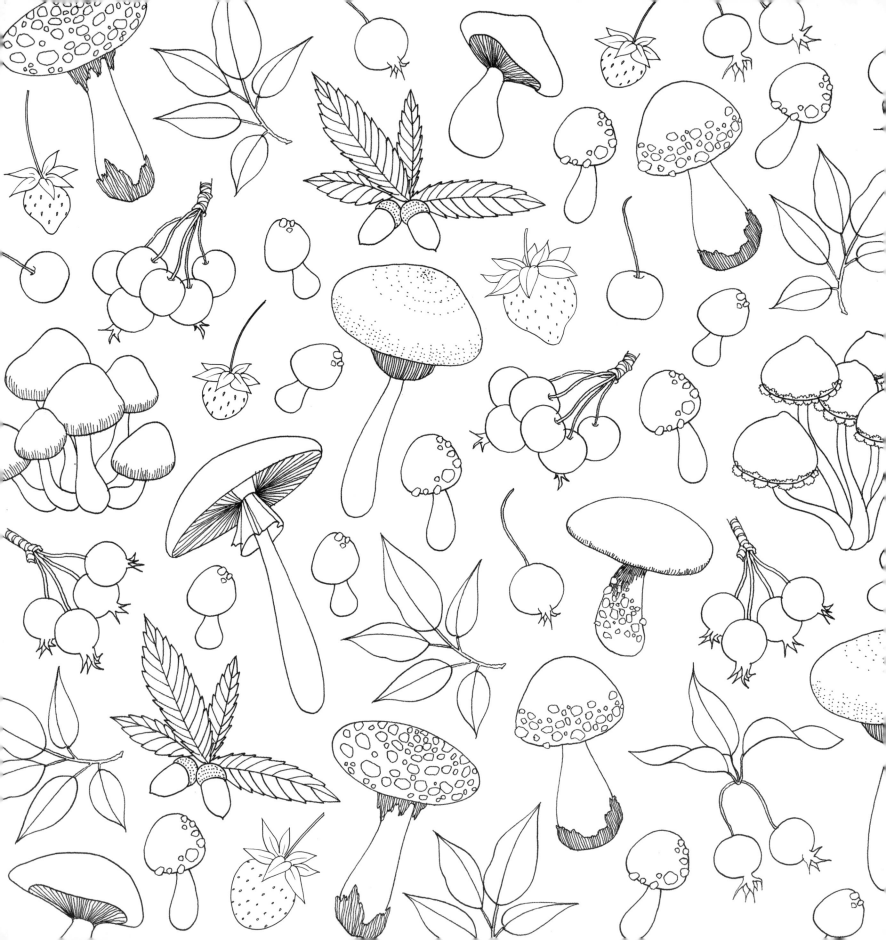

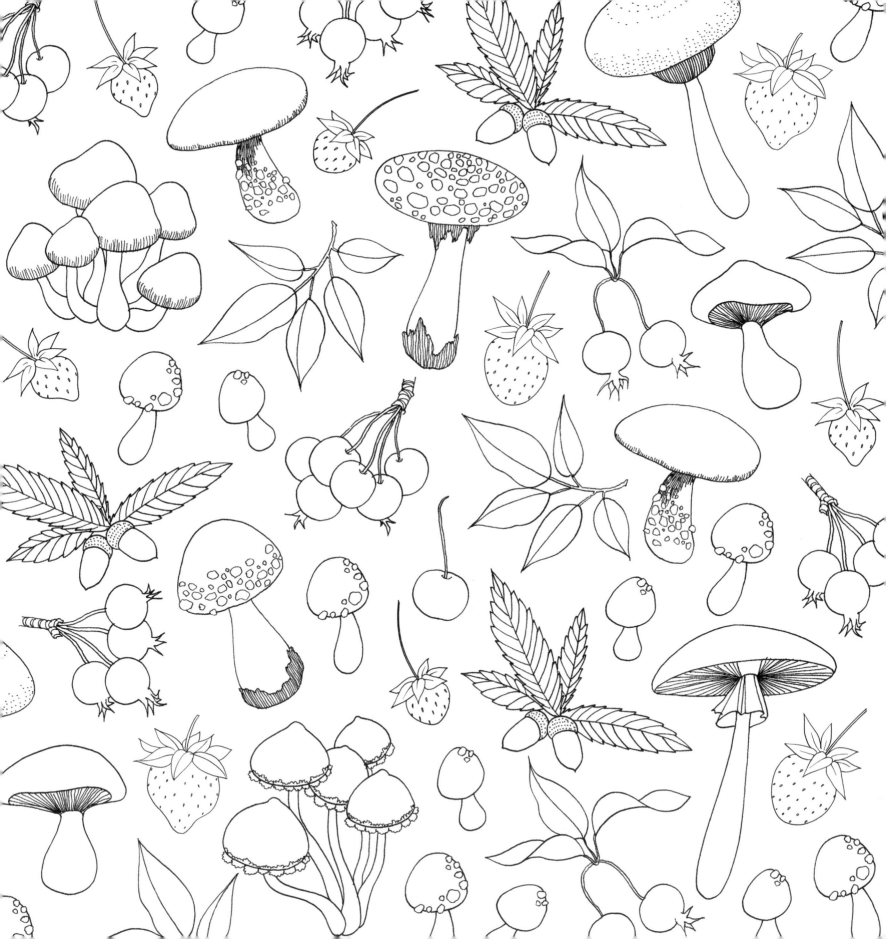

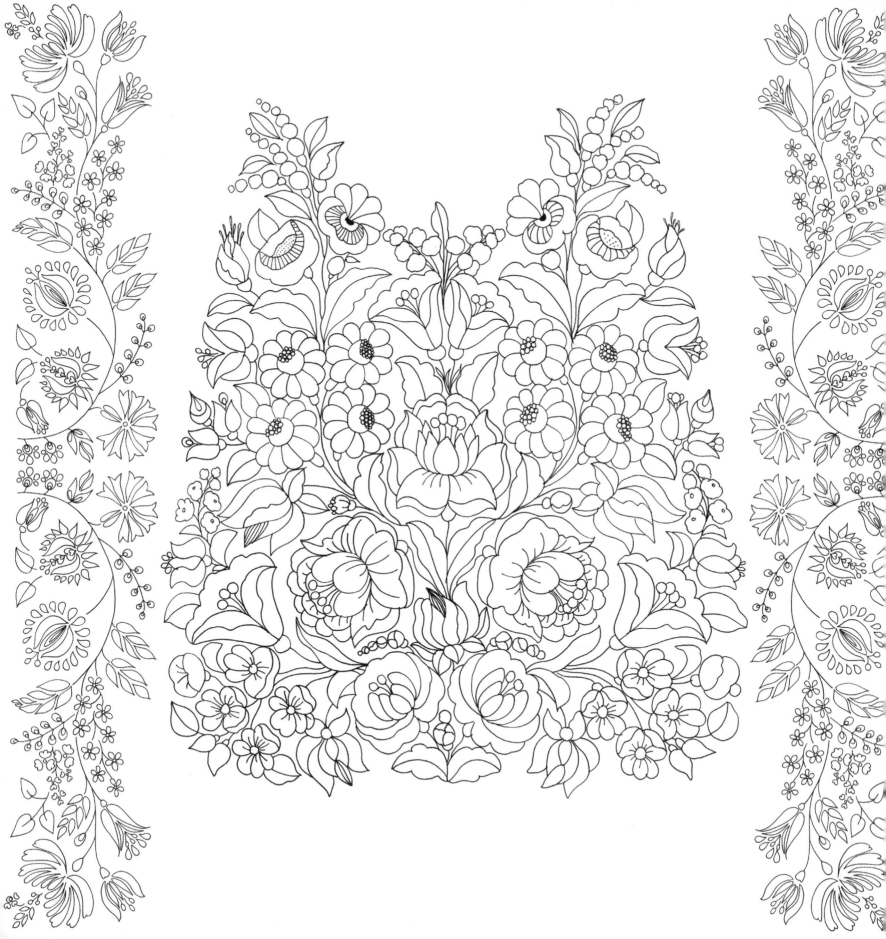

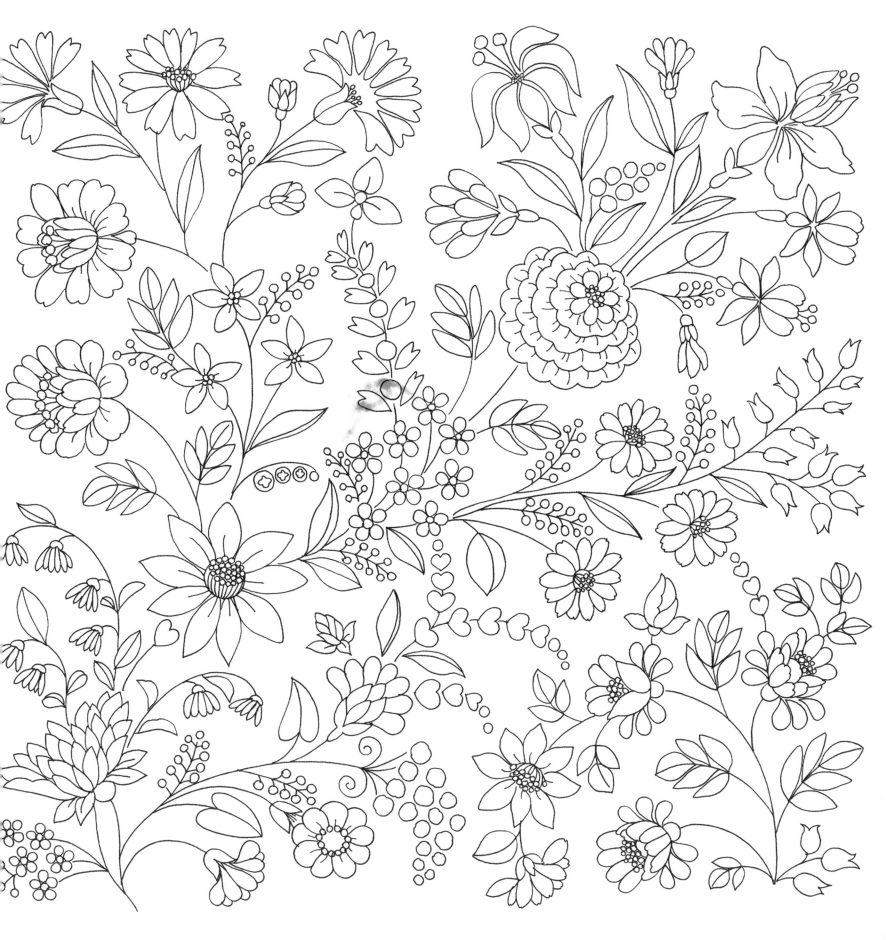

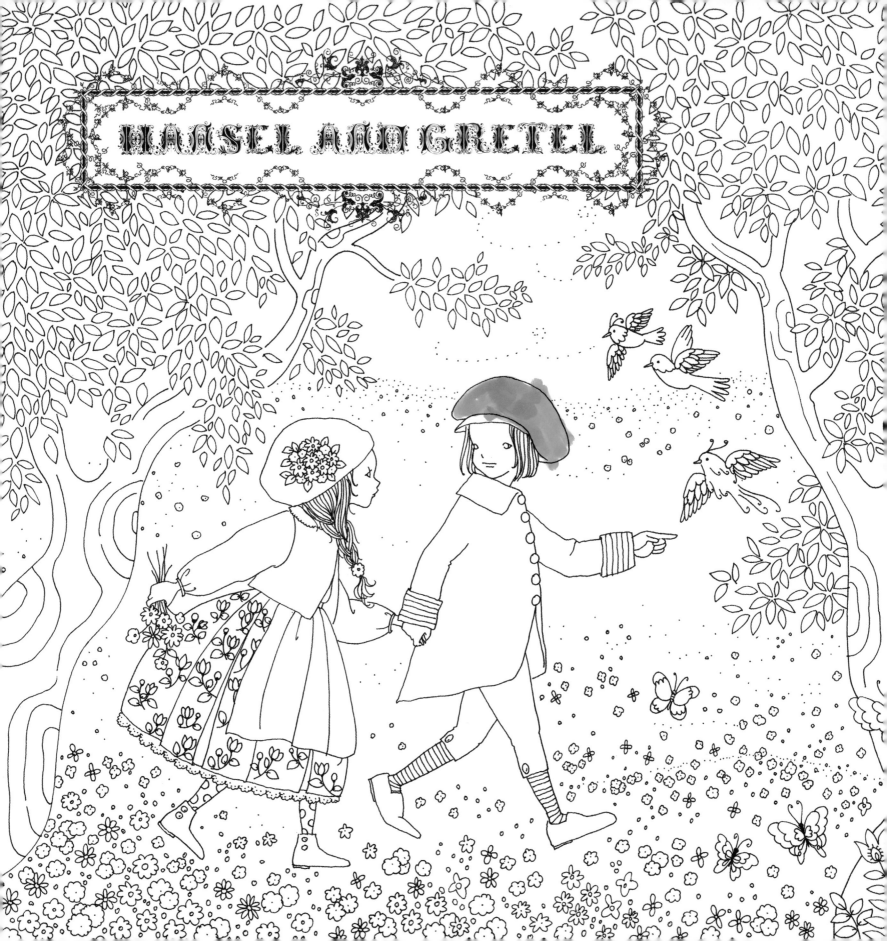

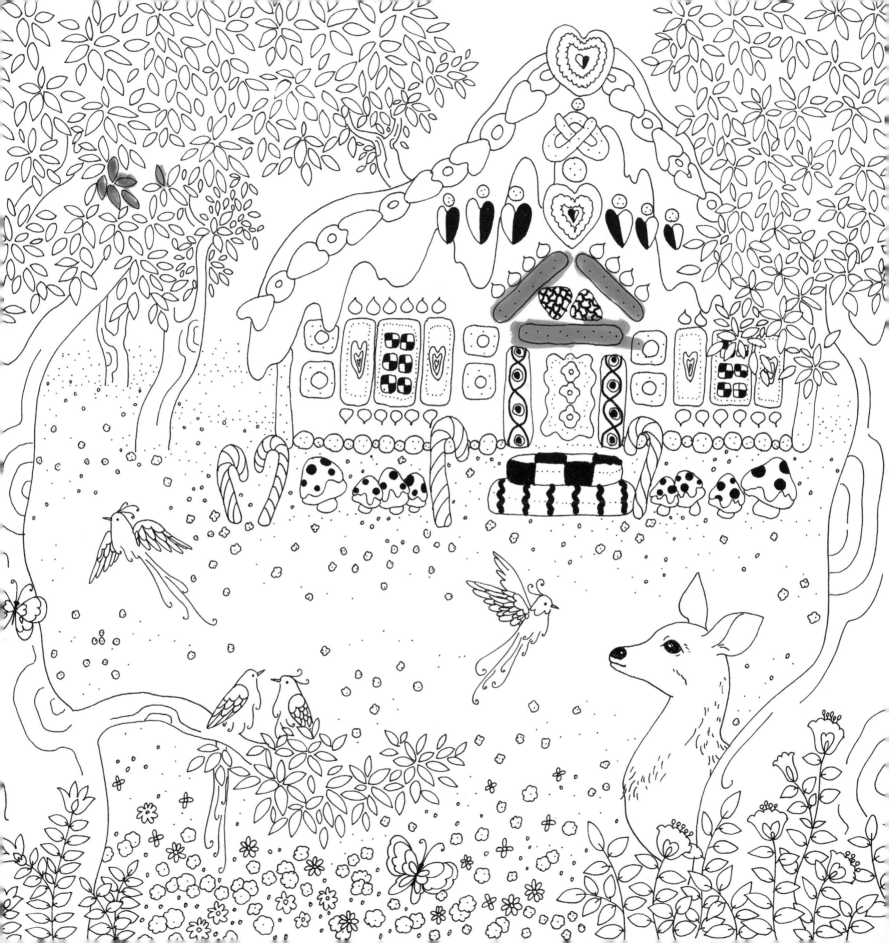

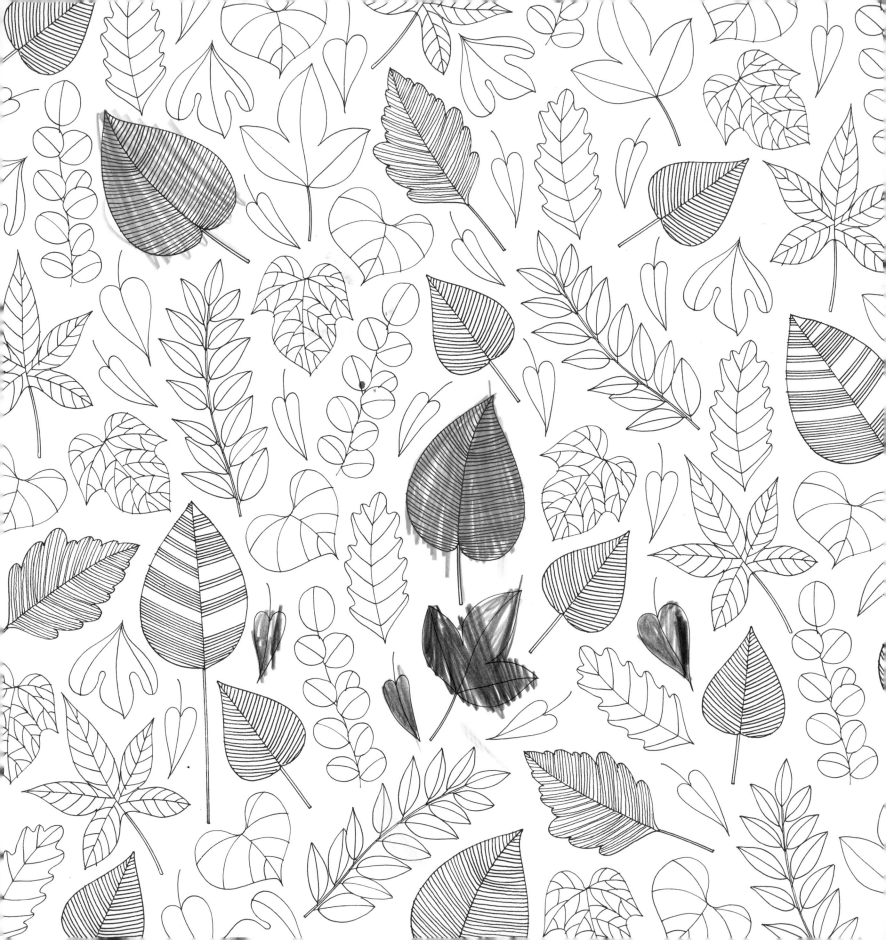

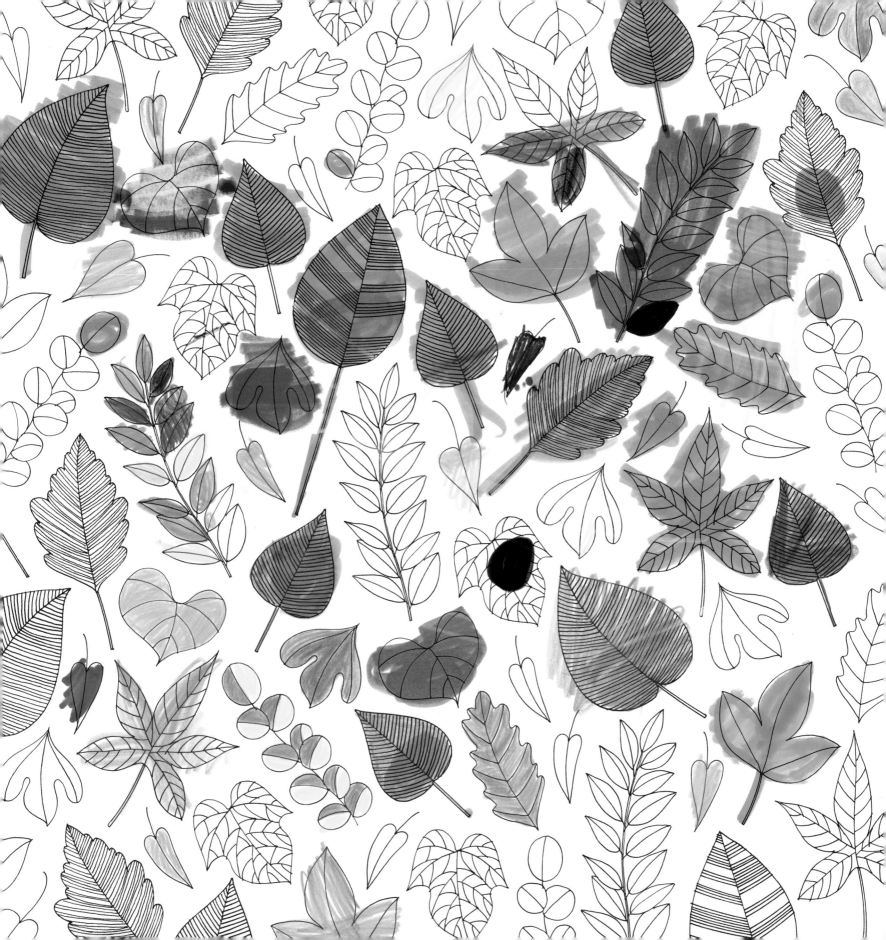

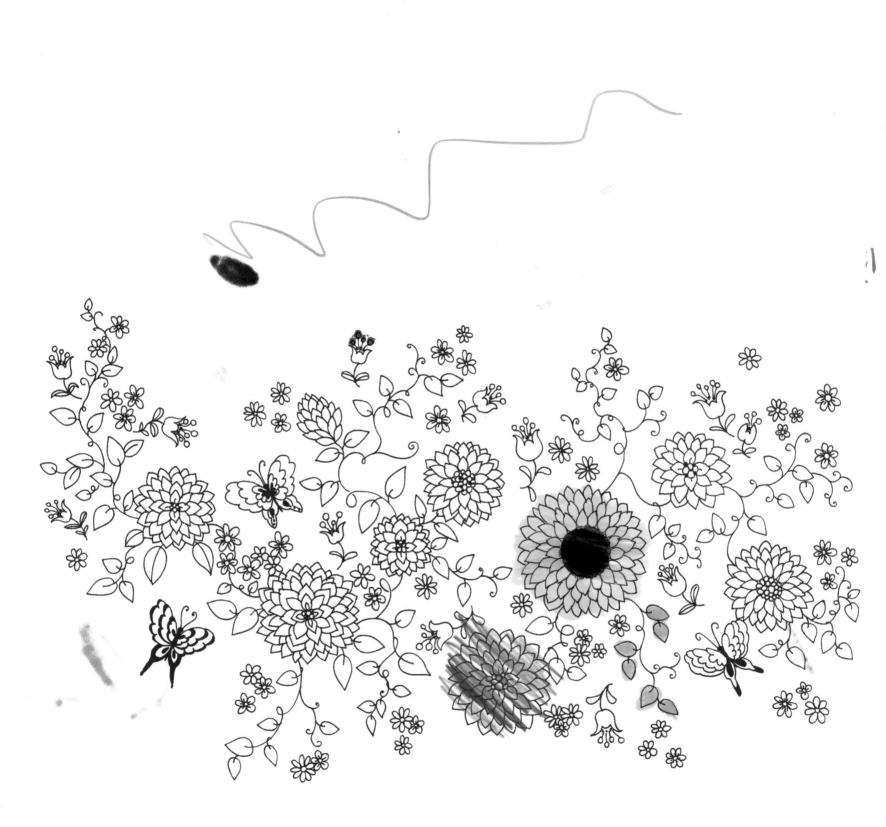

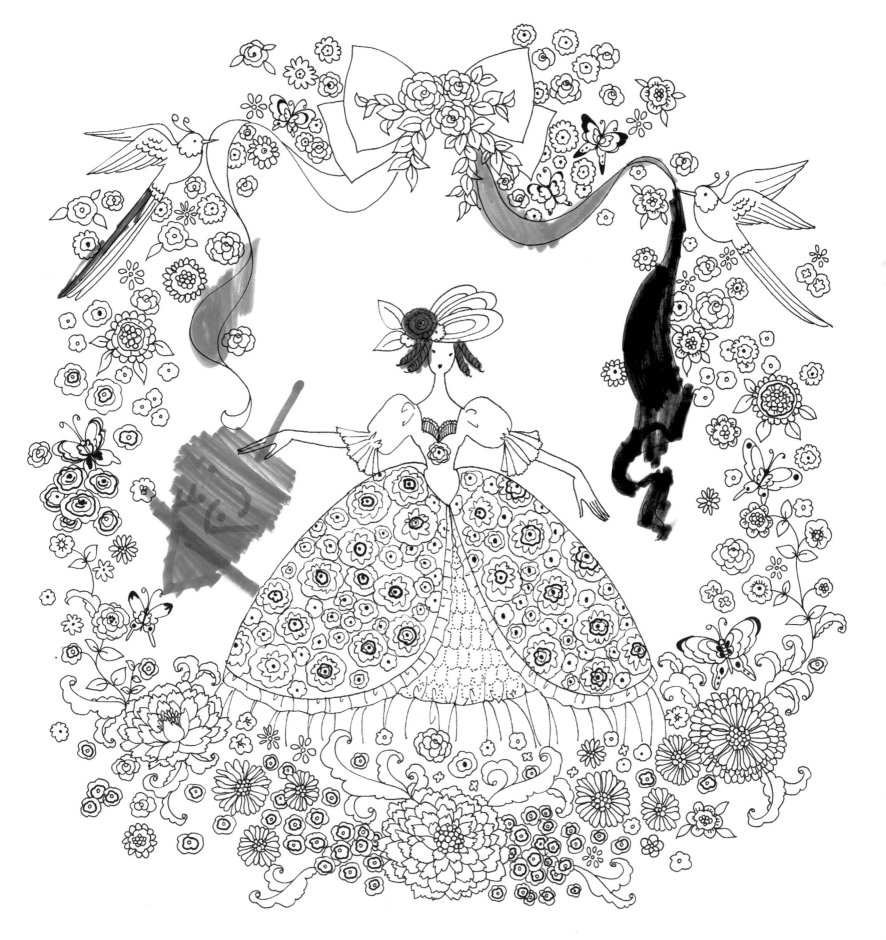

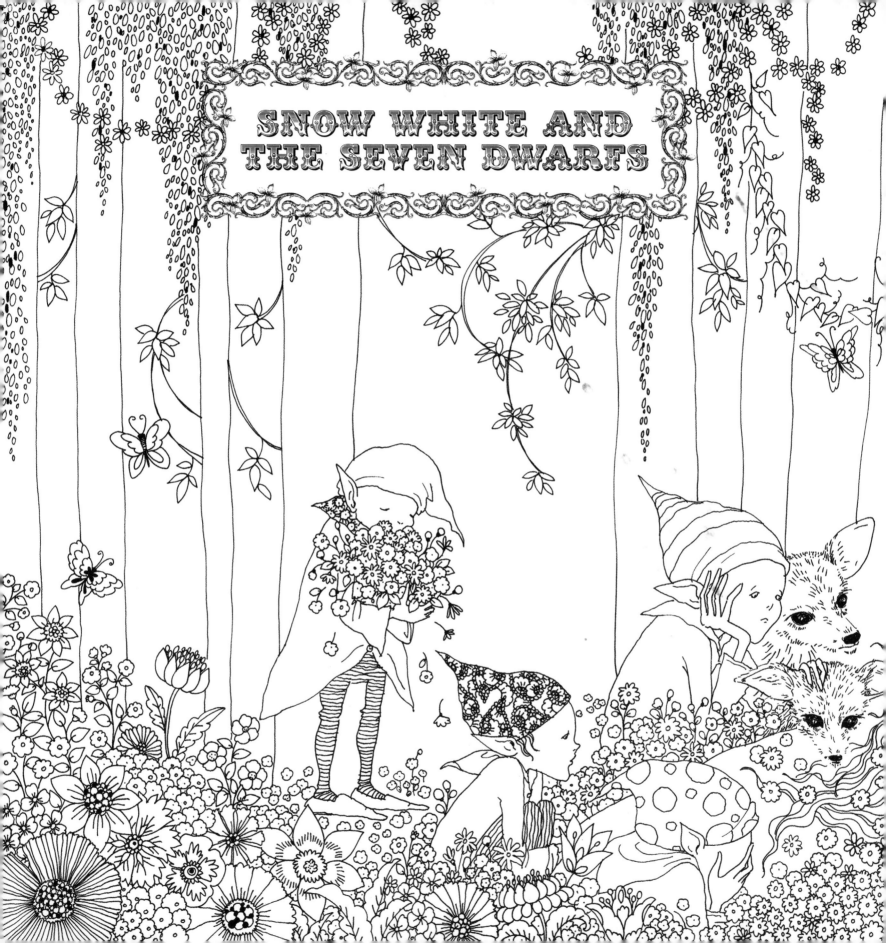

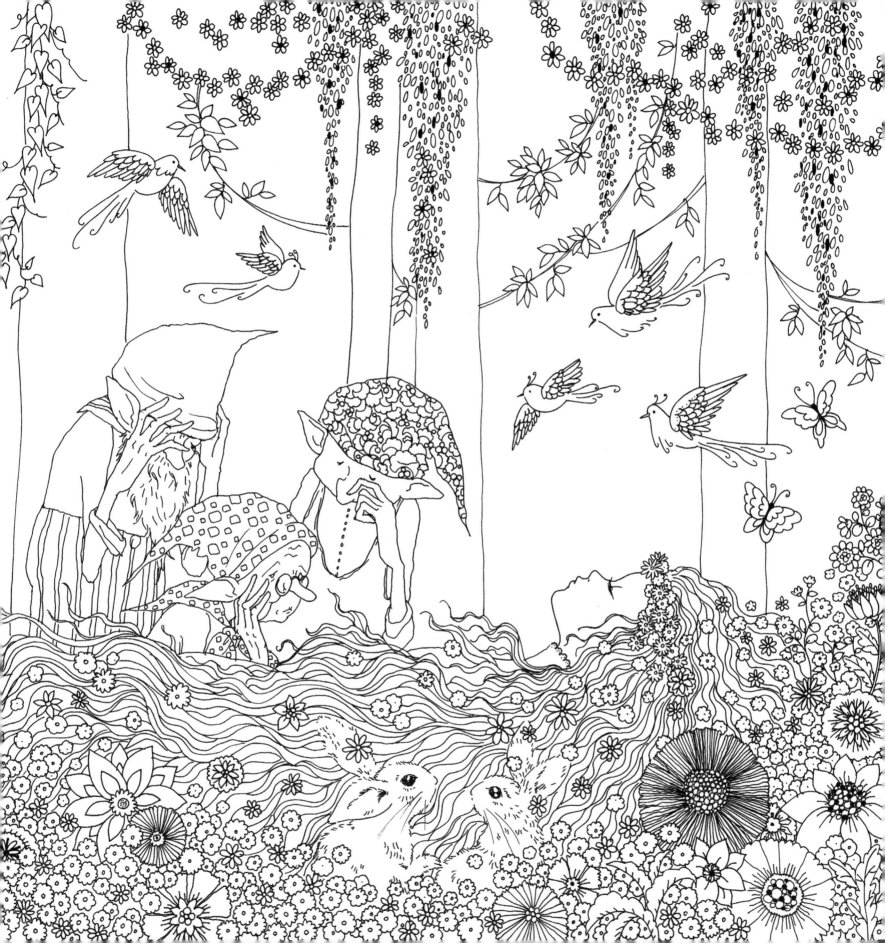

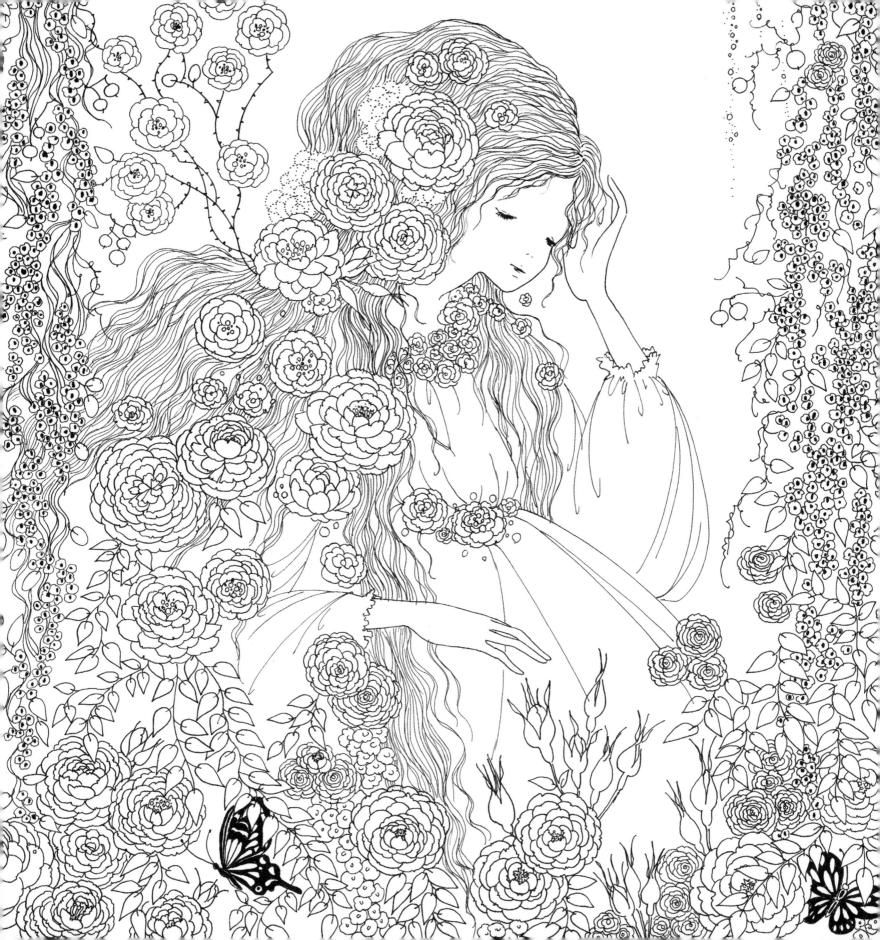

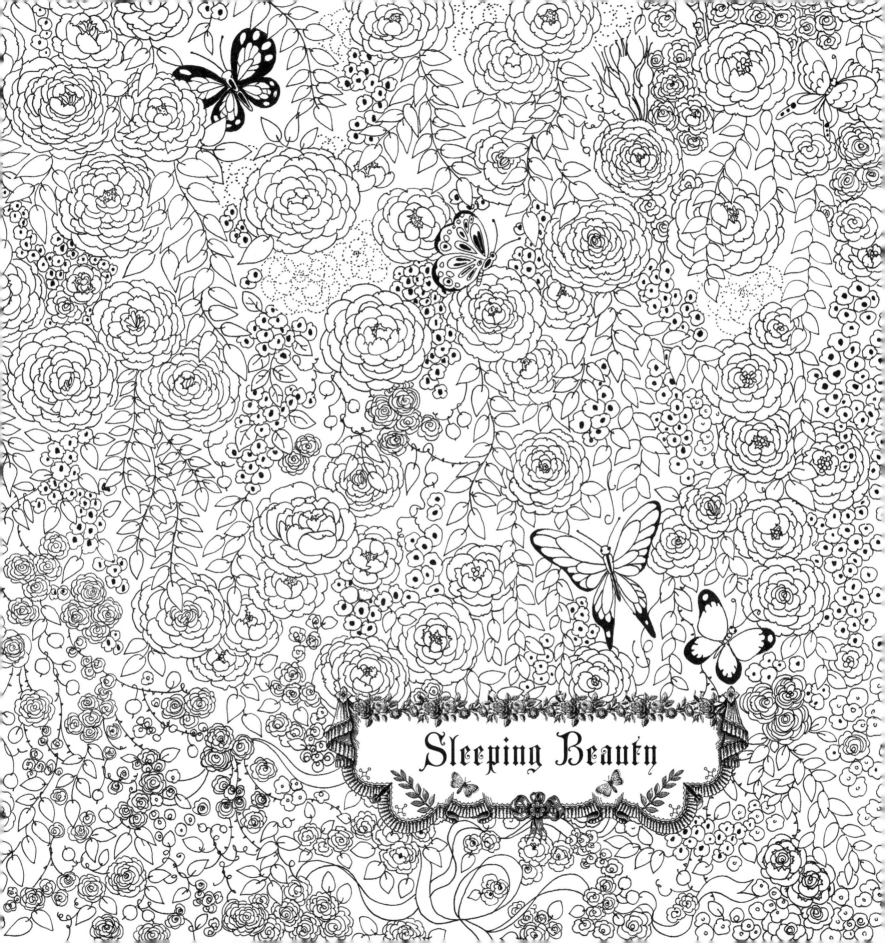

Sleeping Beauty

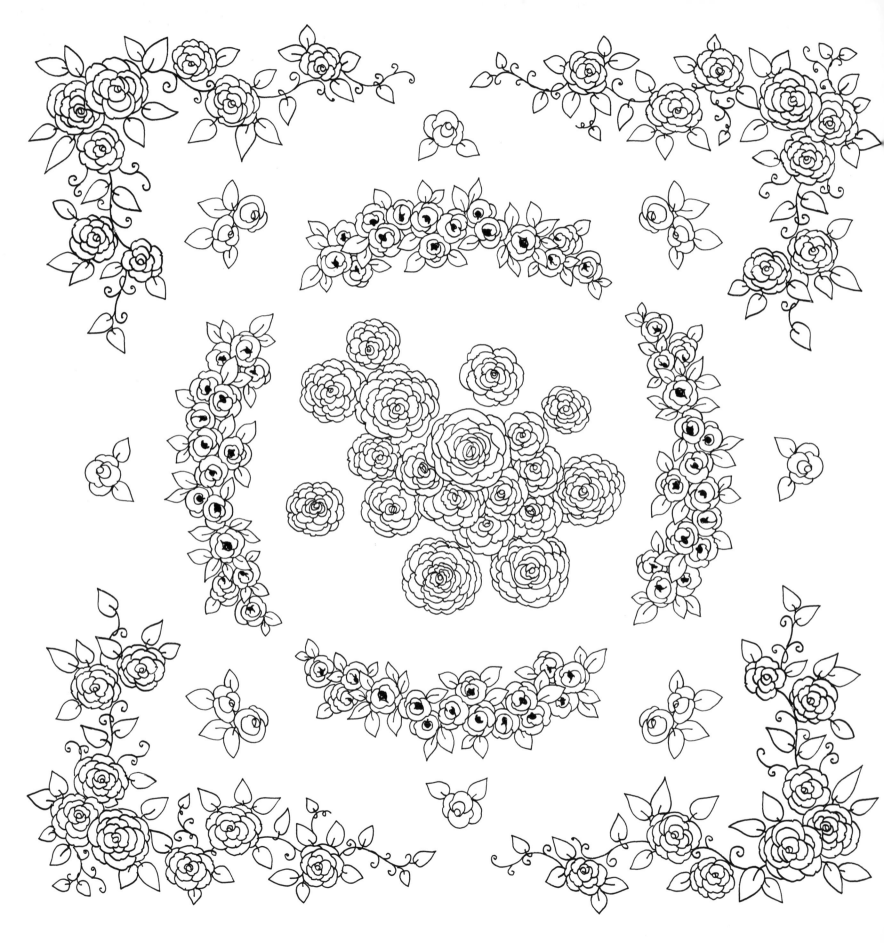

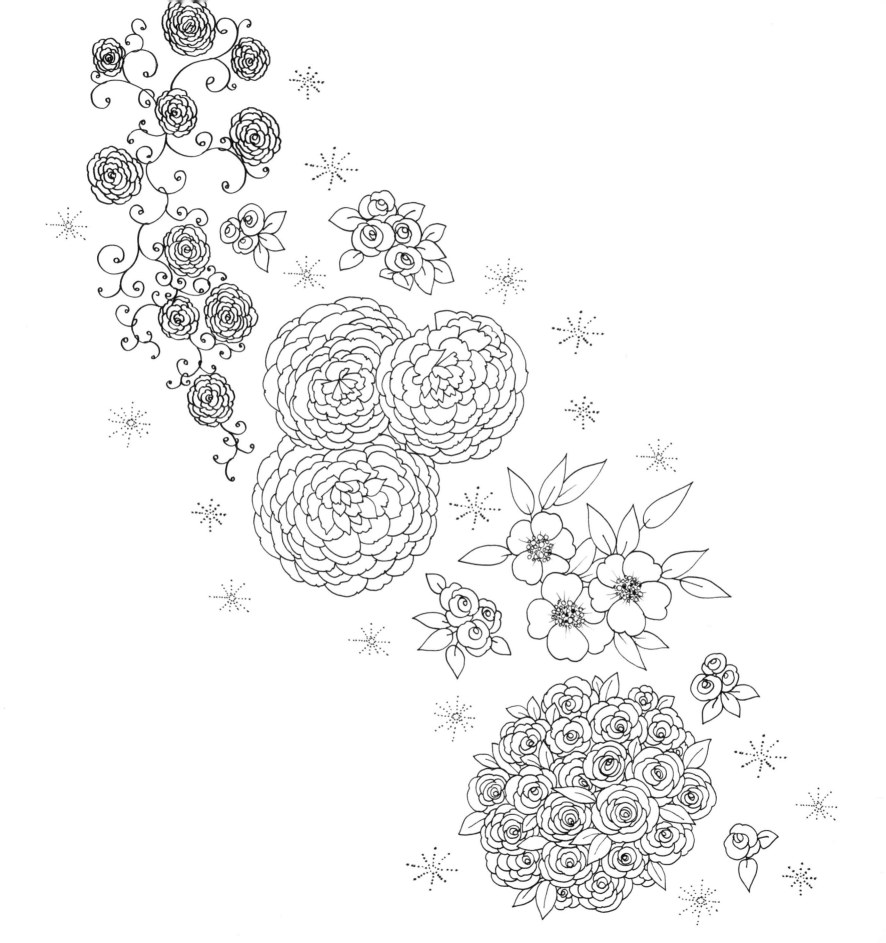

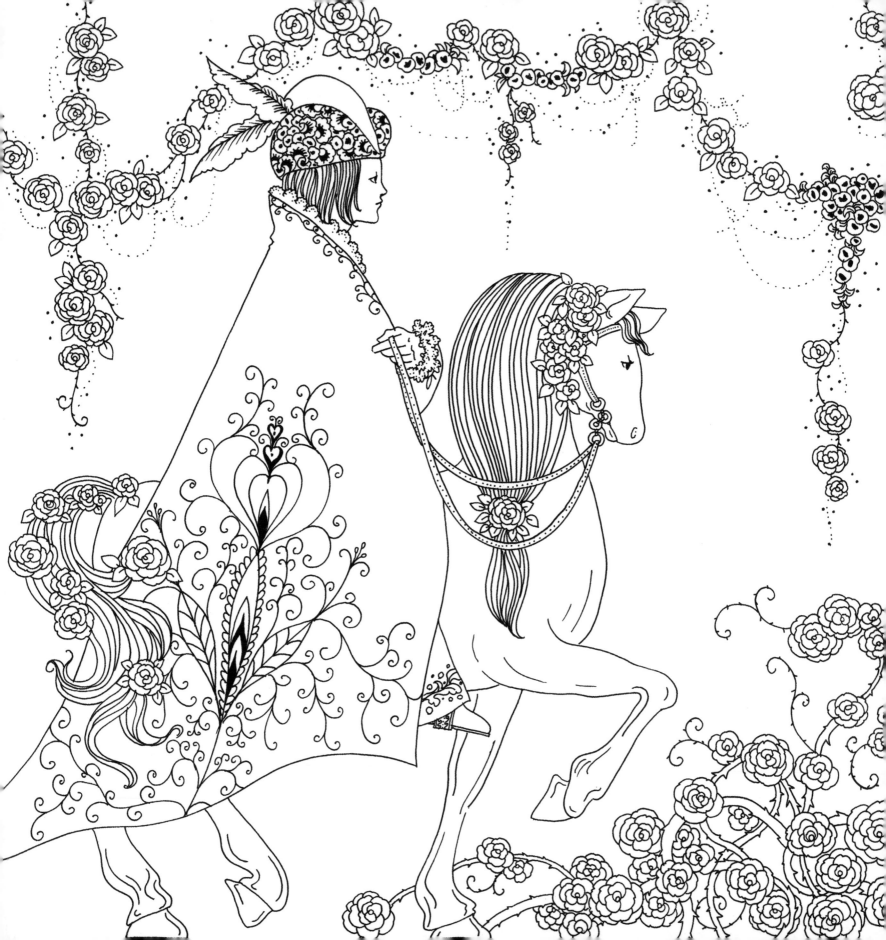

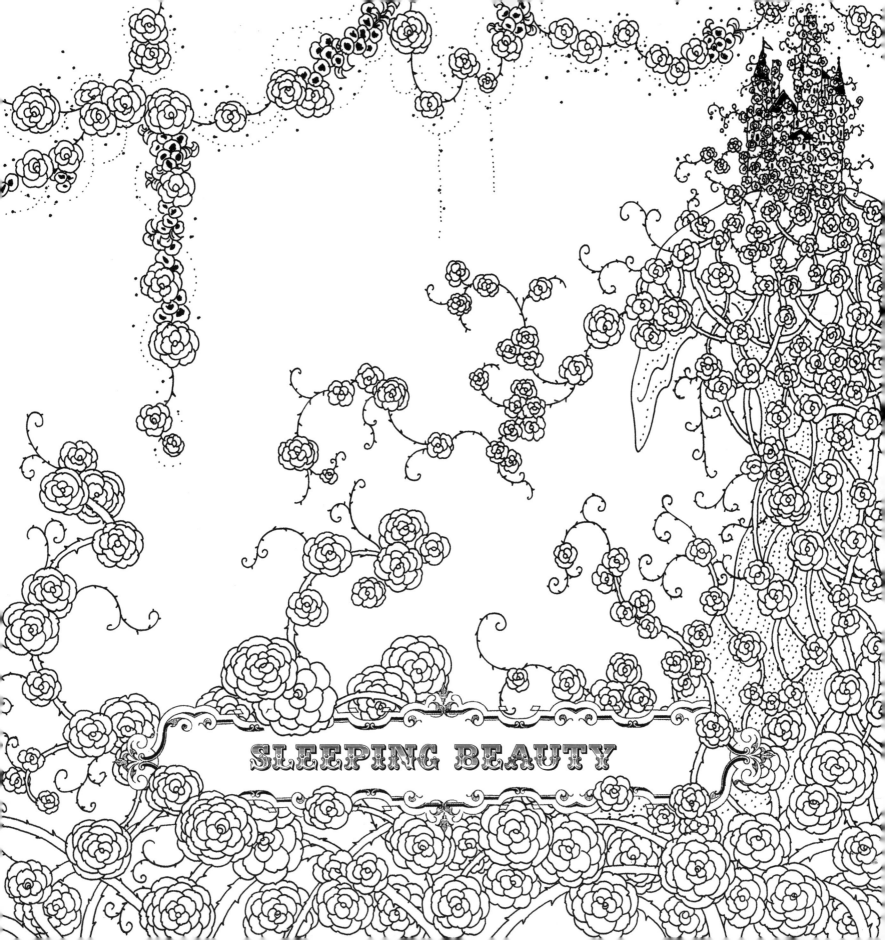

SLEEPING BEAUTY

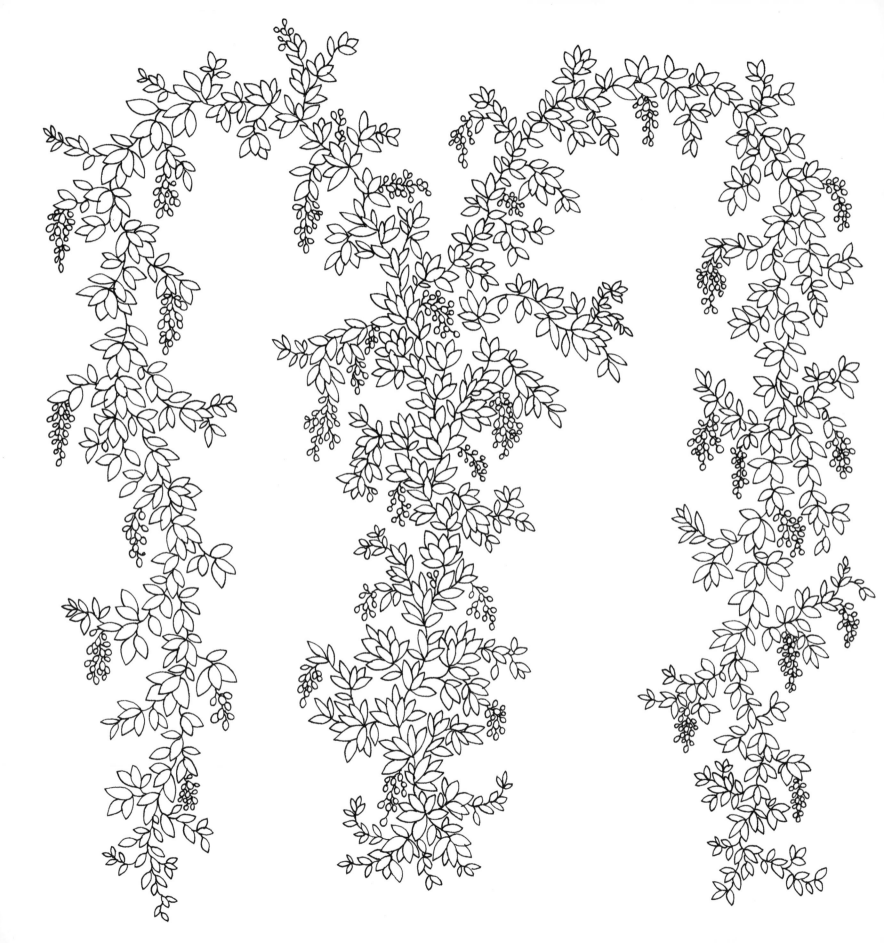

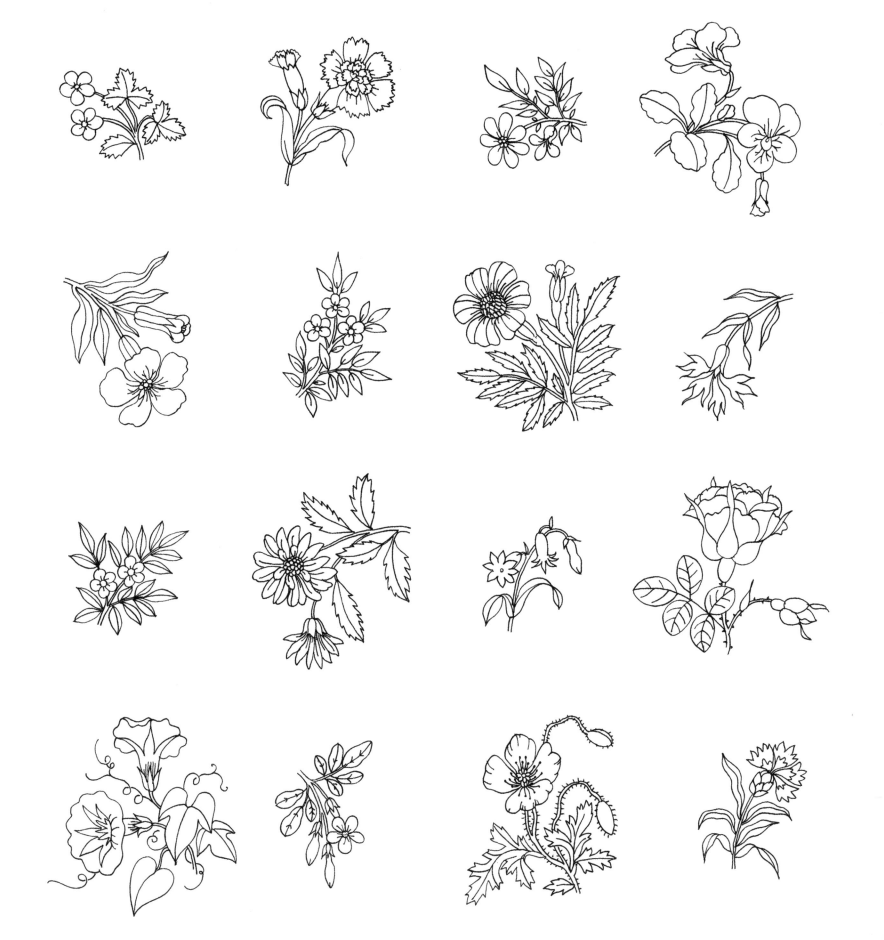

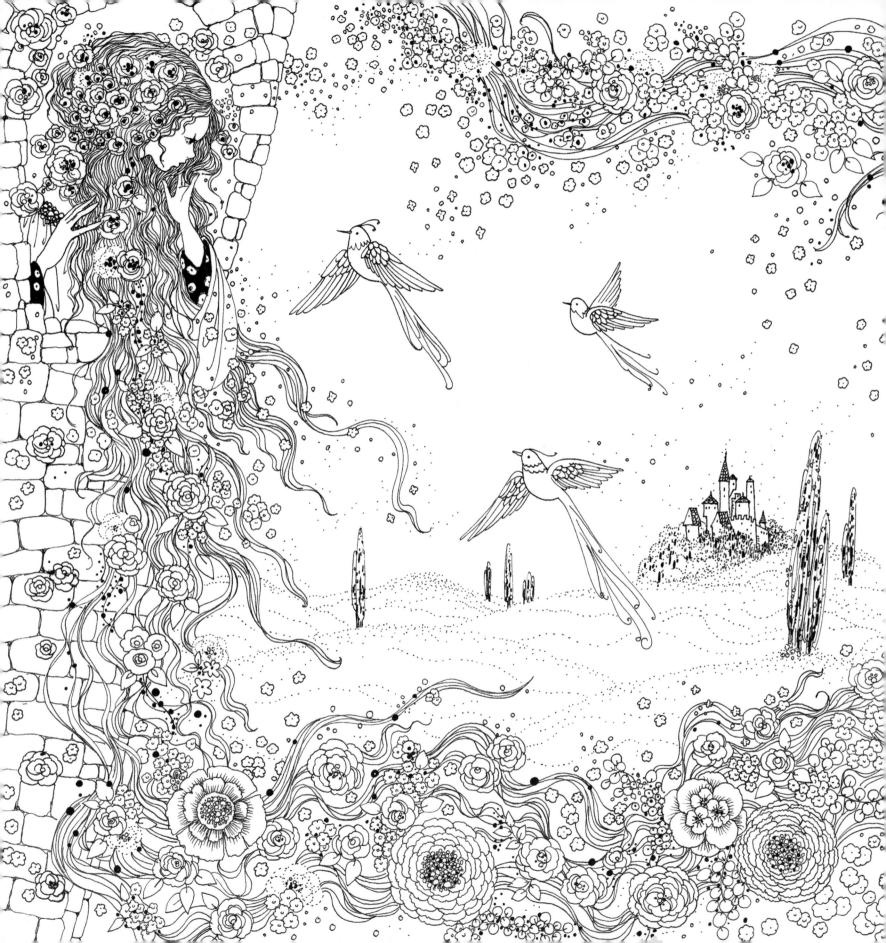

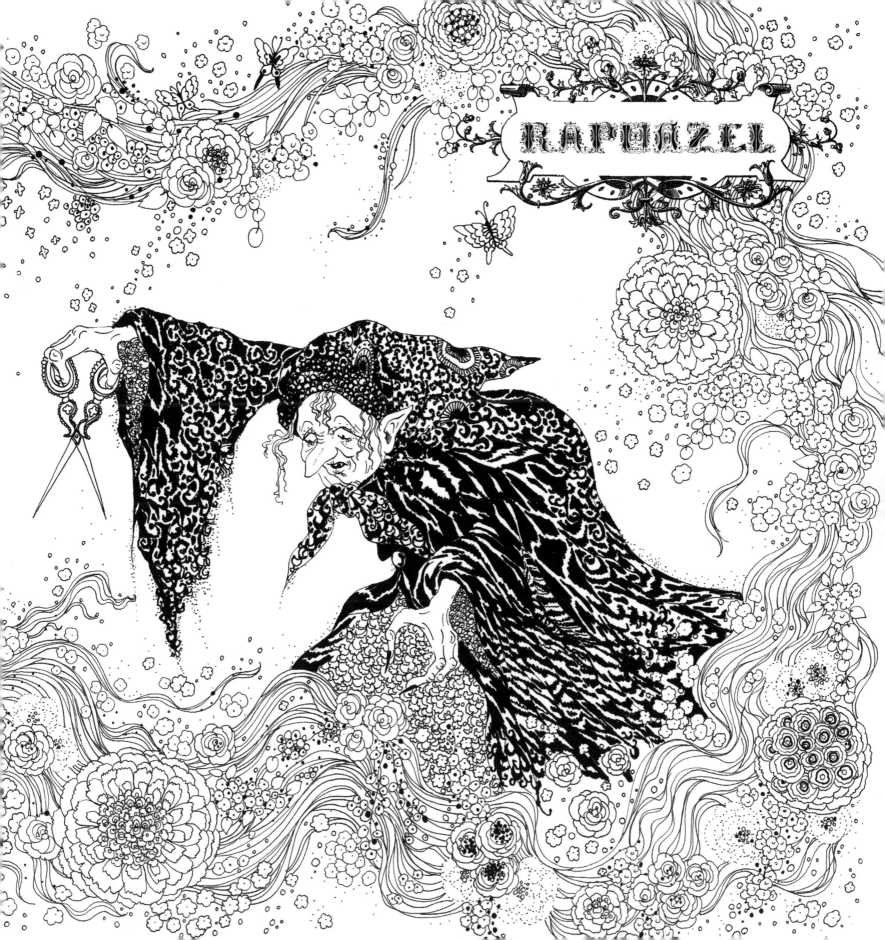

RAPUNZEL

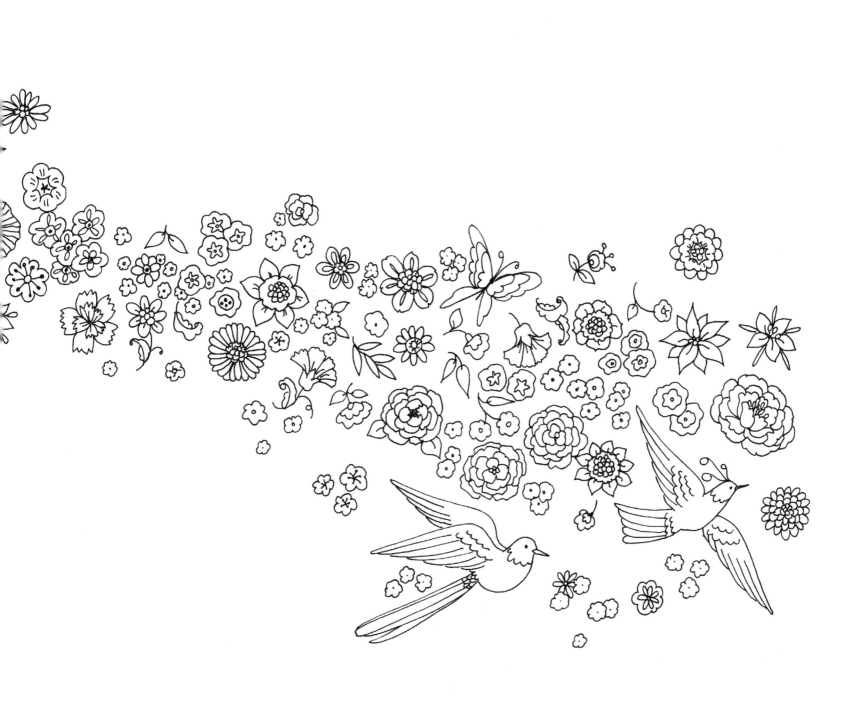

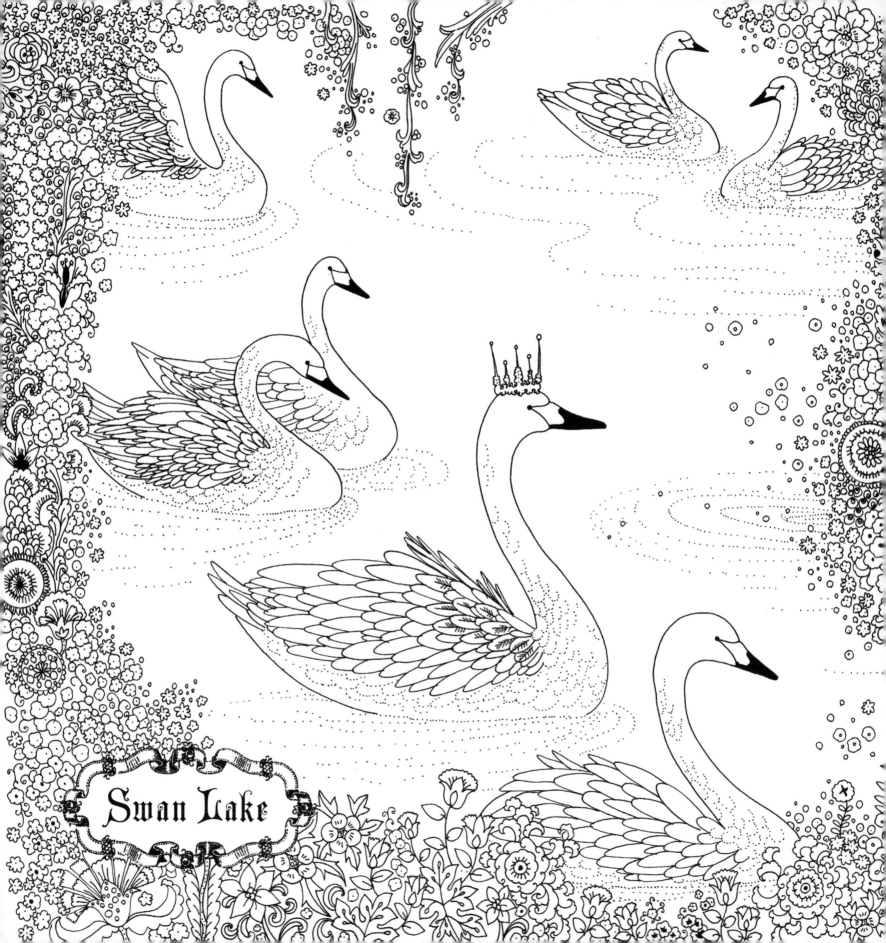

Swan Lake

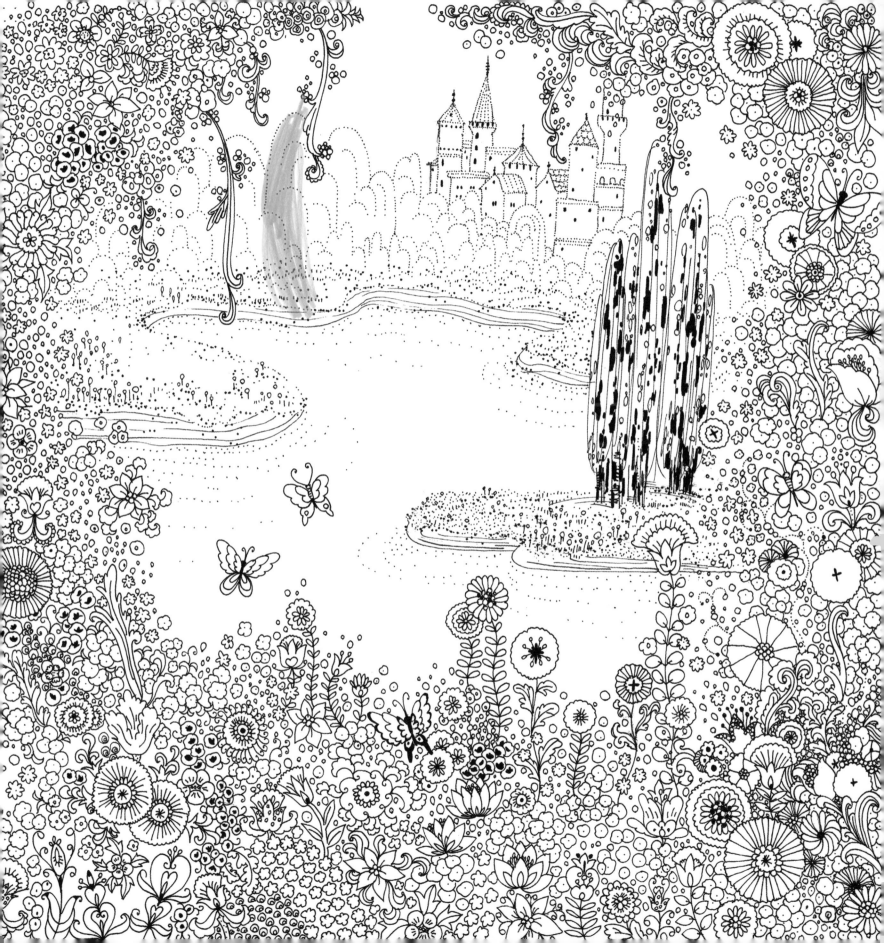

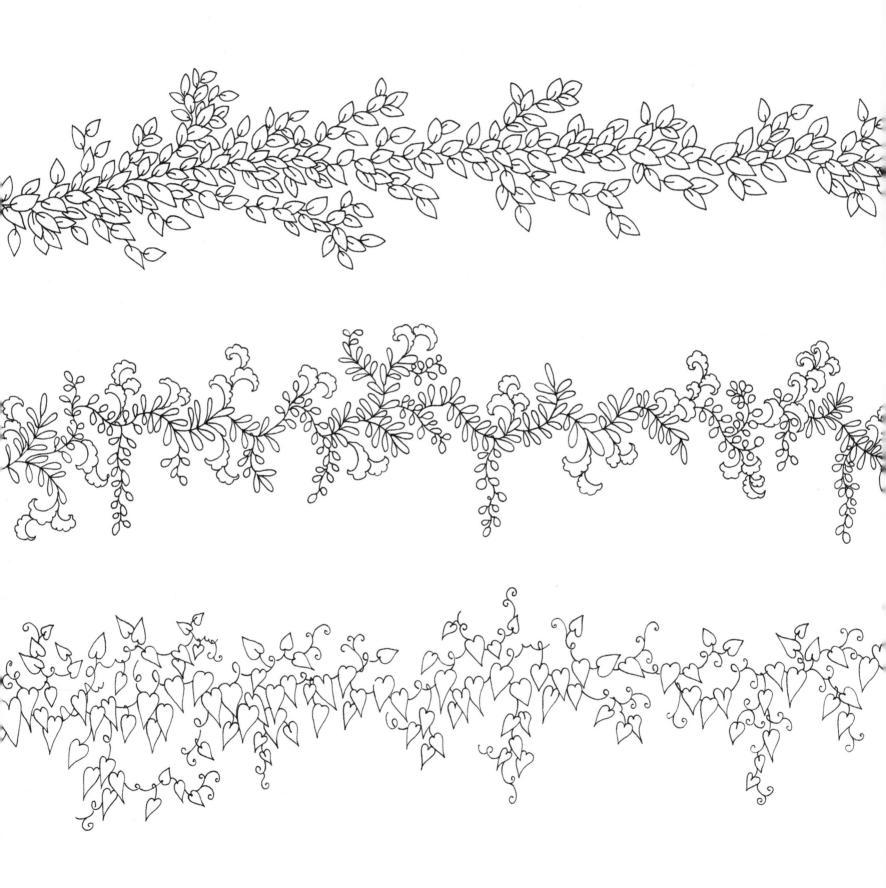

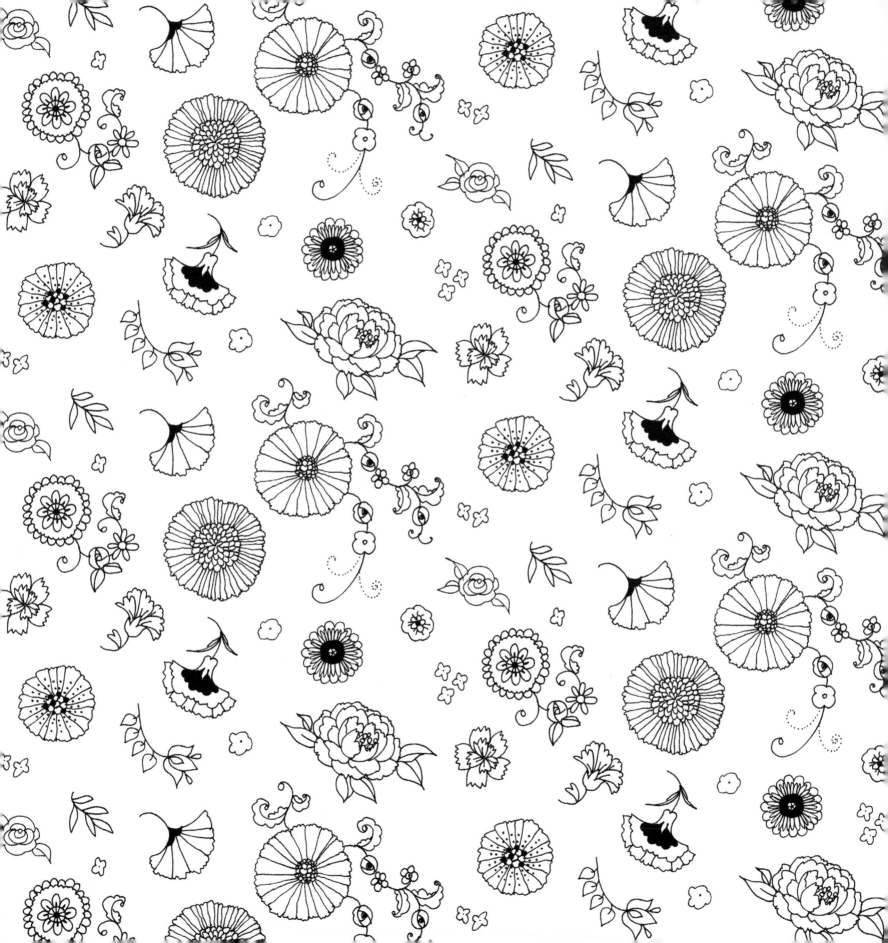

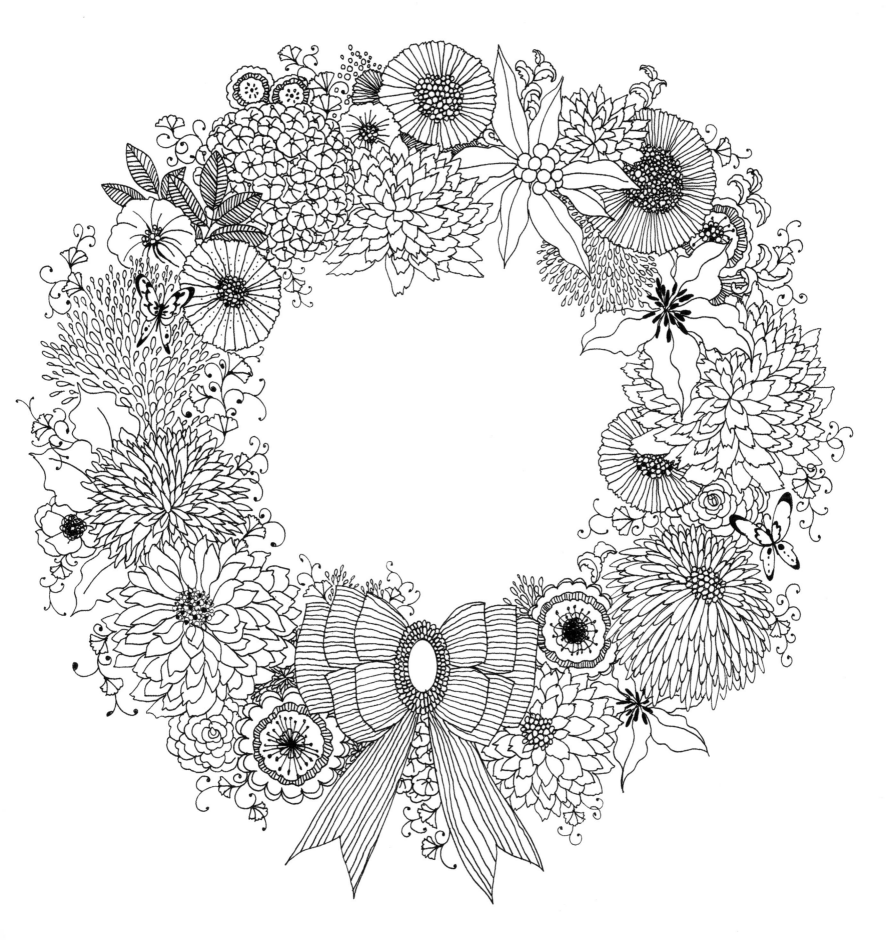

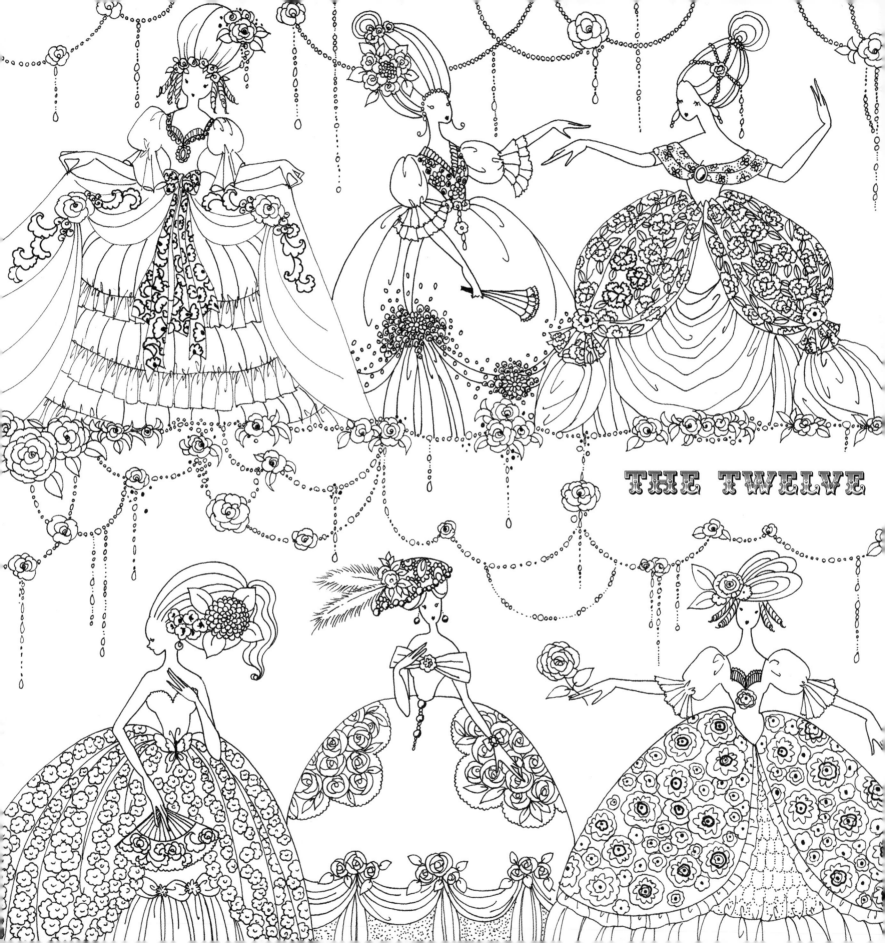

THE TWELVE

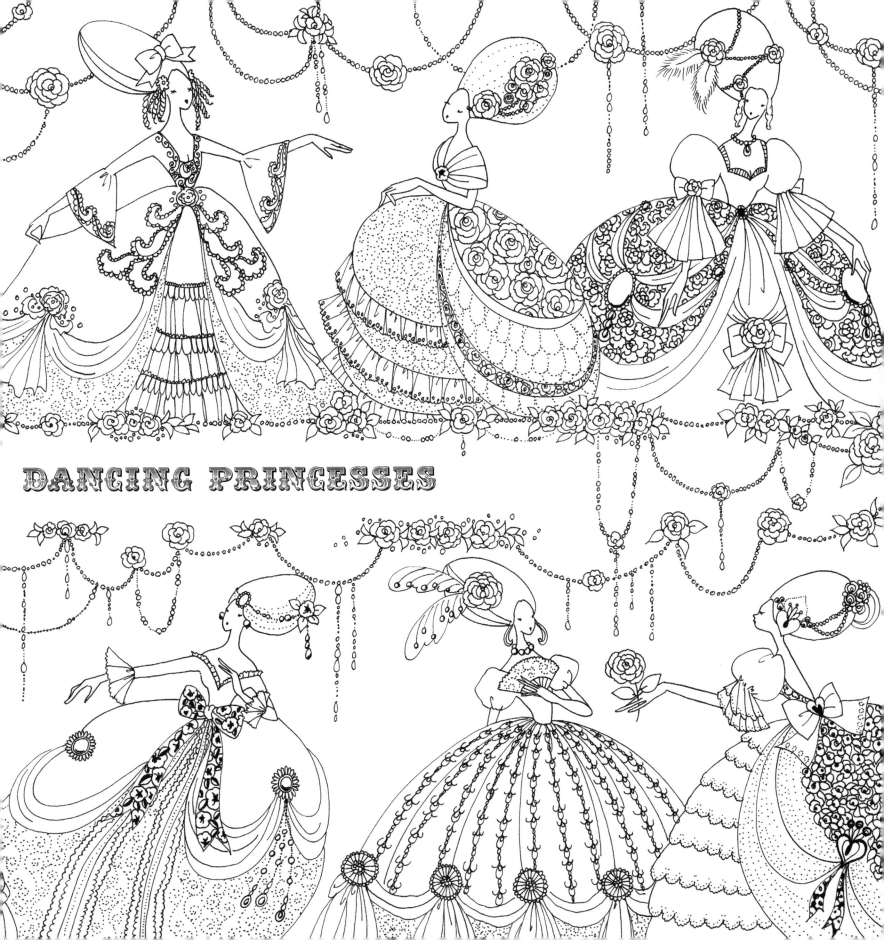

DANCING PRINCESSES

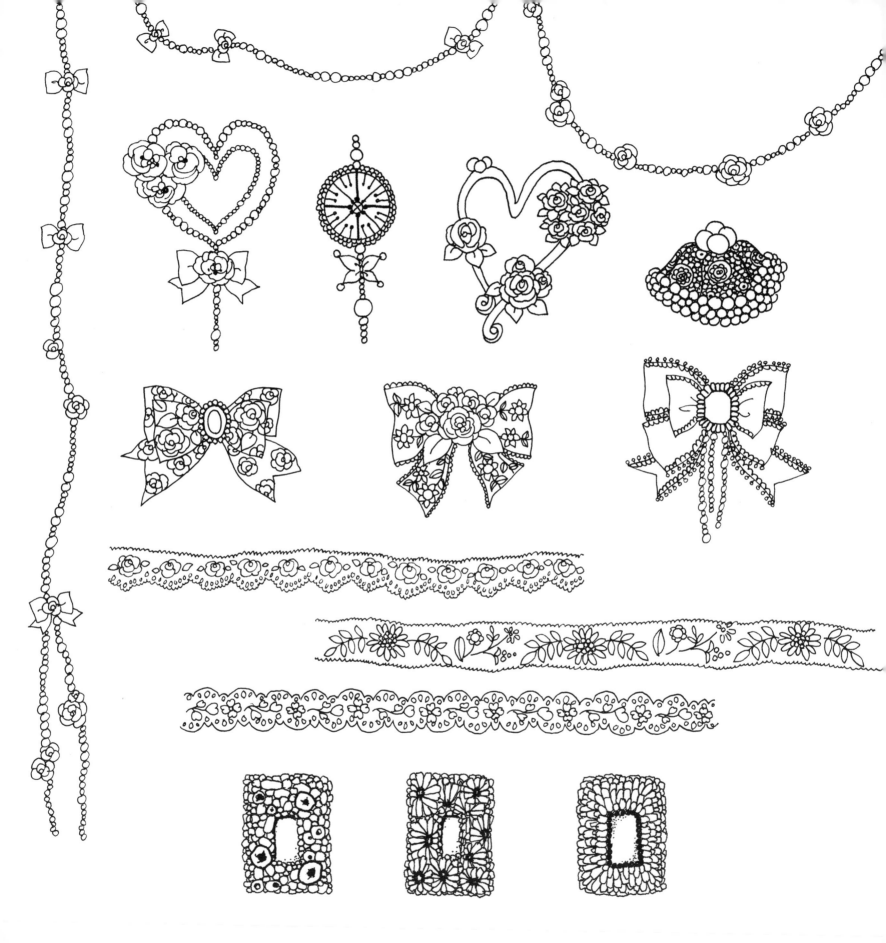

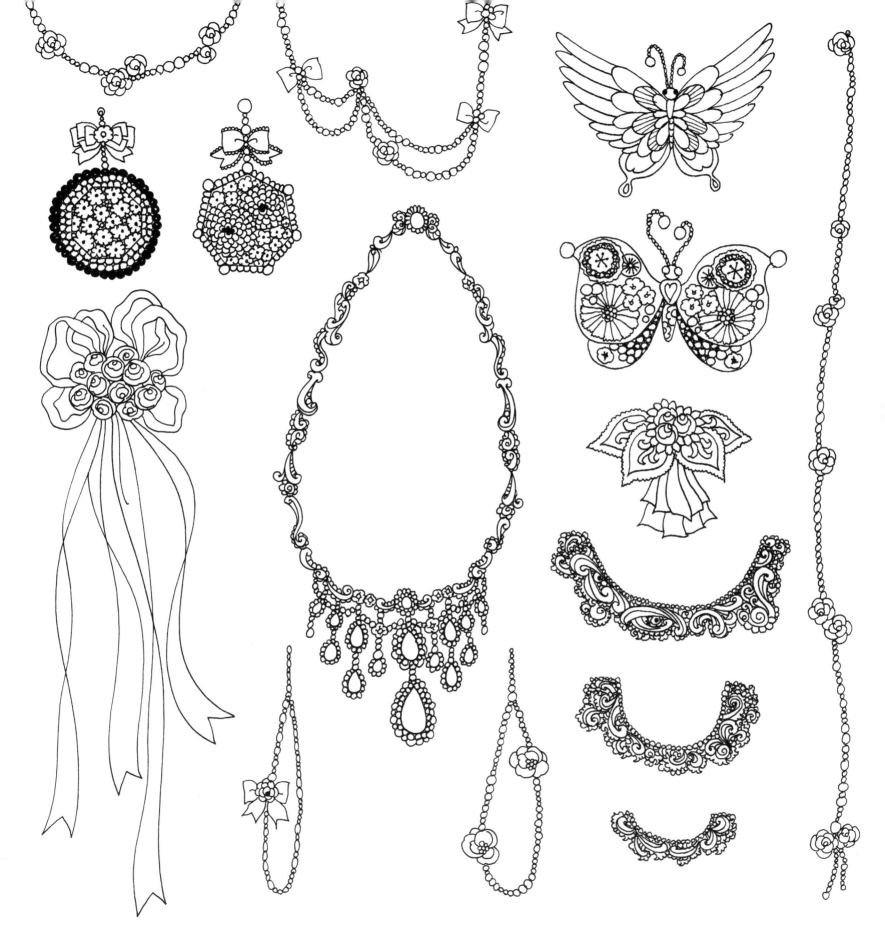

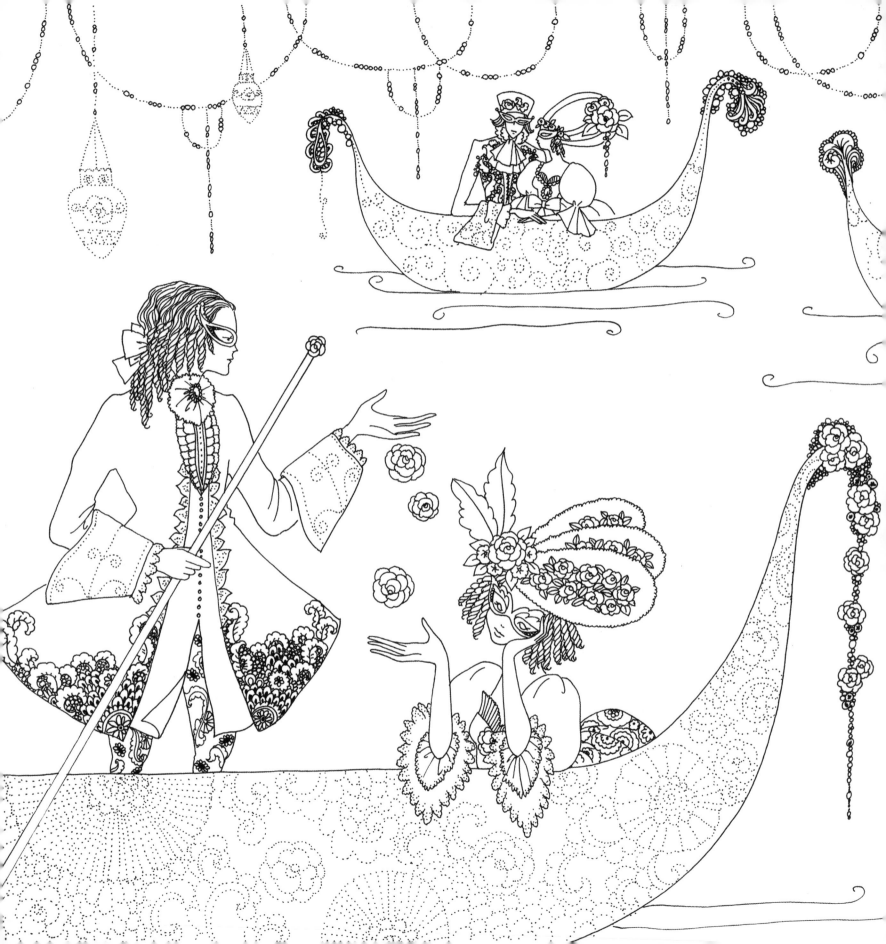

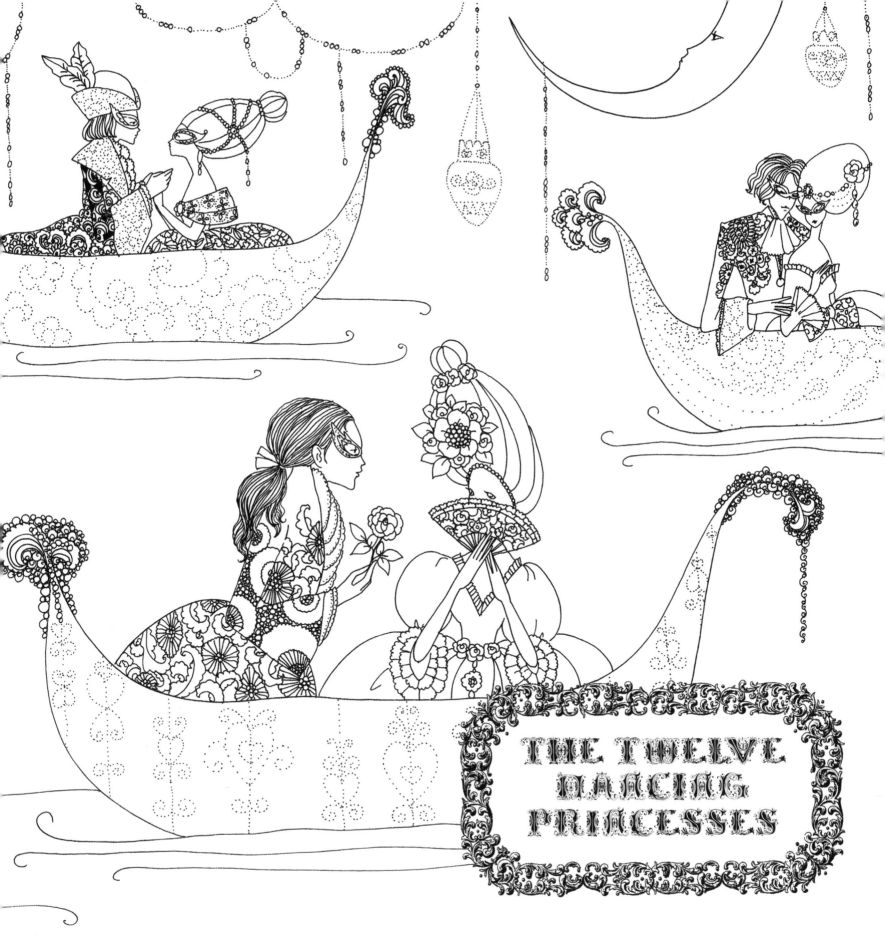

THE TWELVE DANCING PRINCESSES

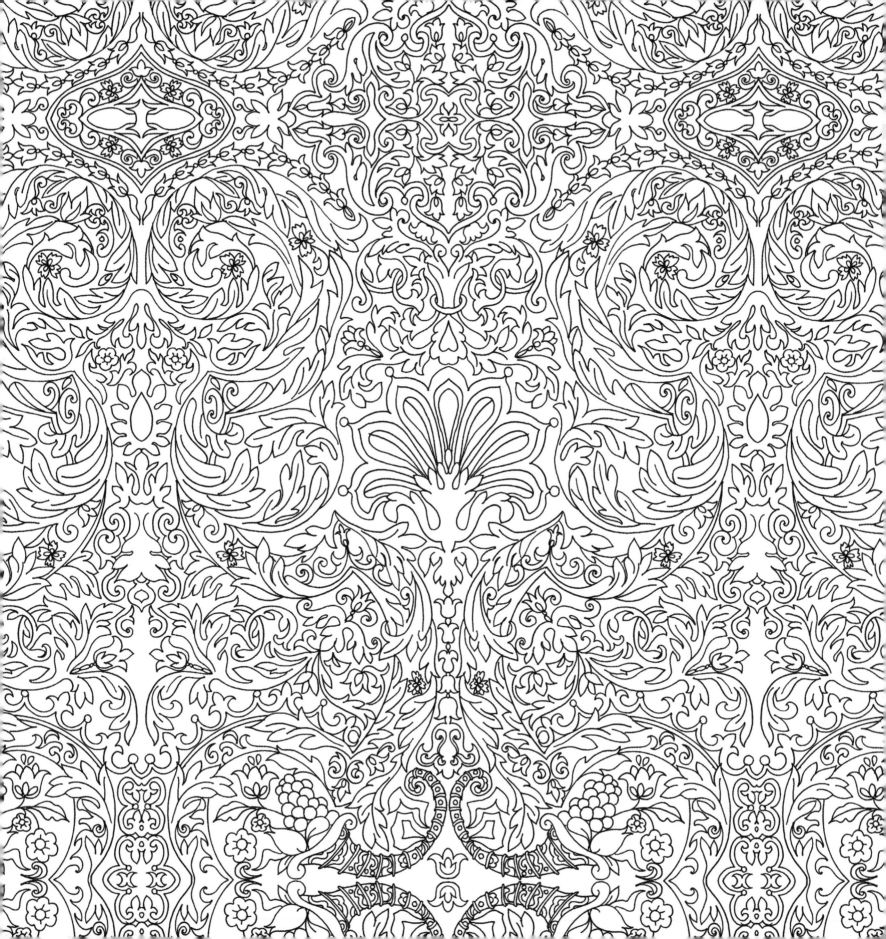

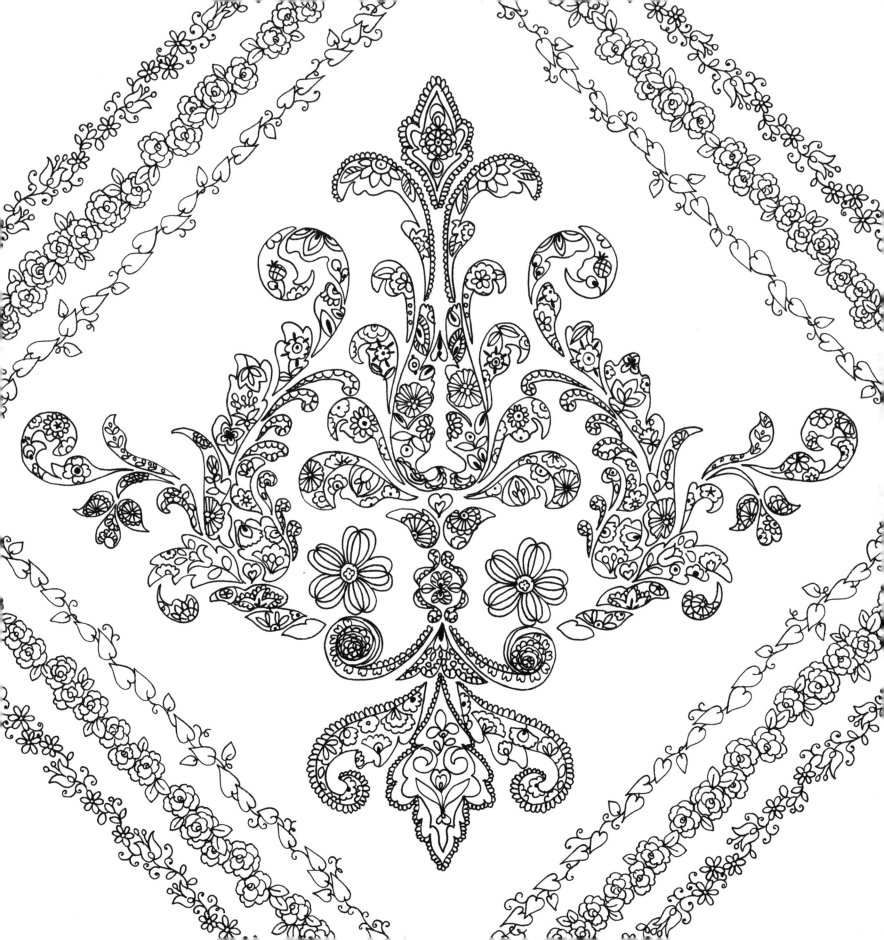

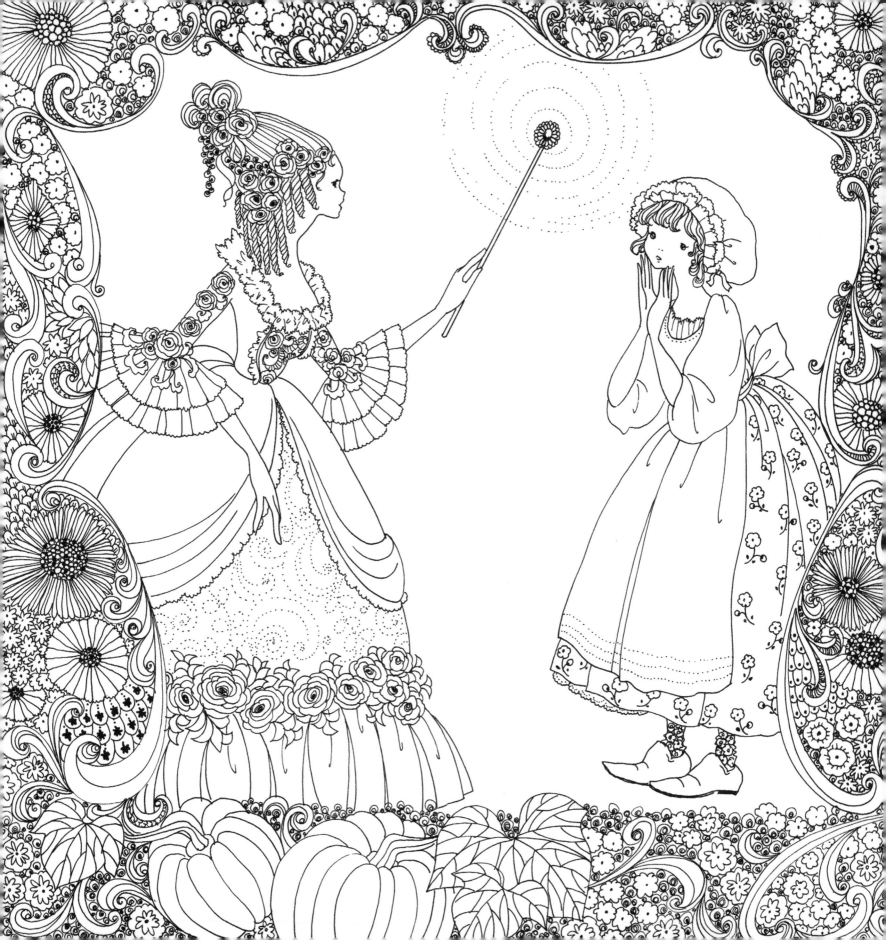

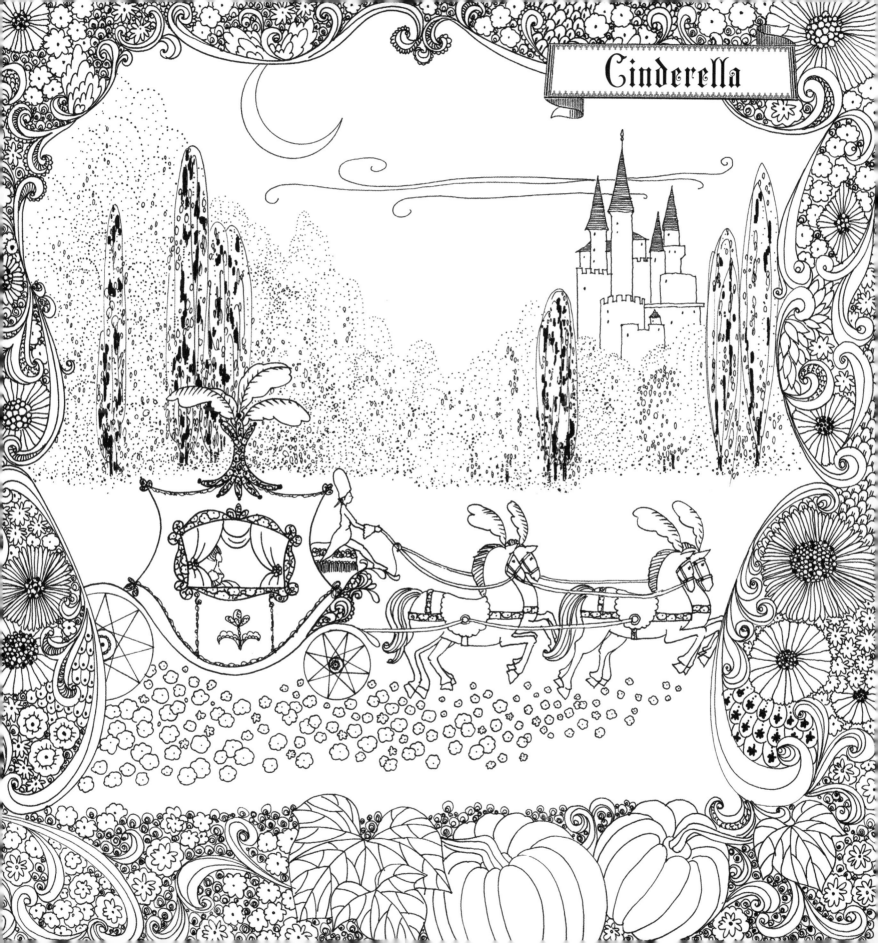

Cinderella

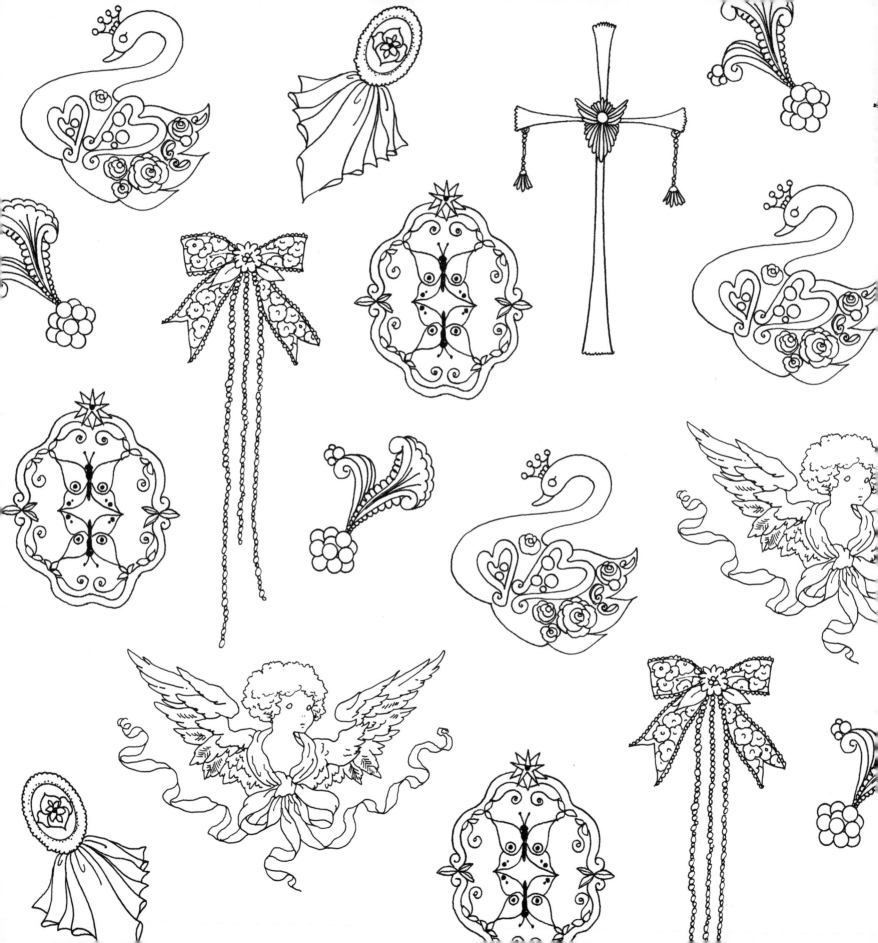

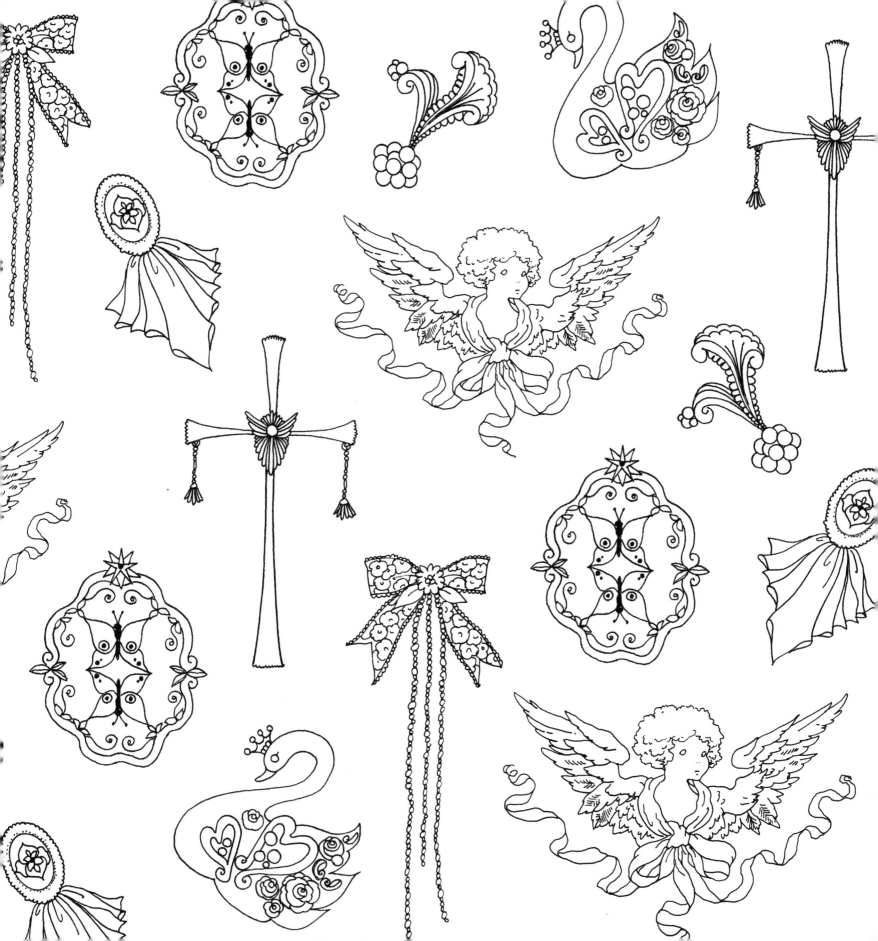

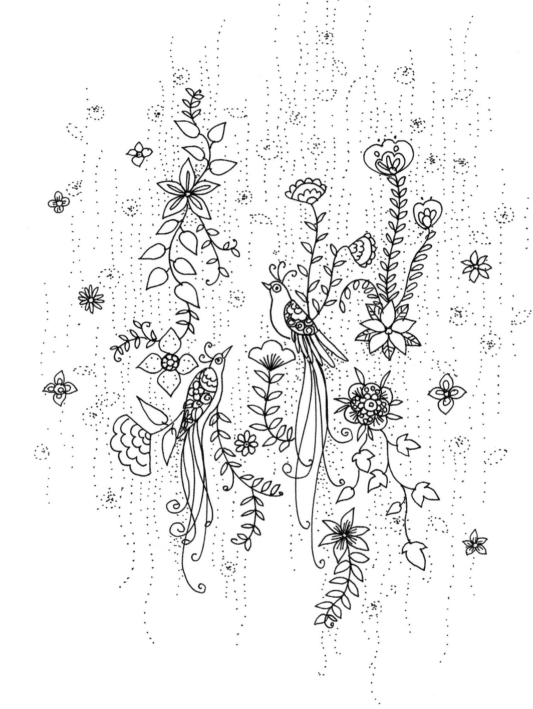

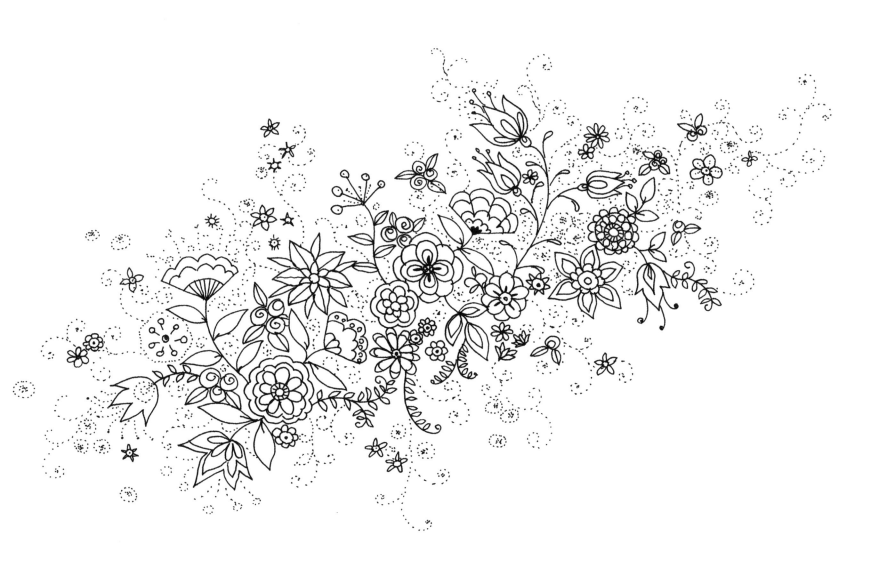

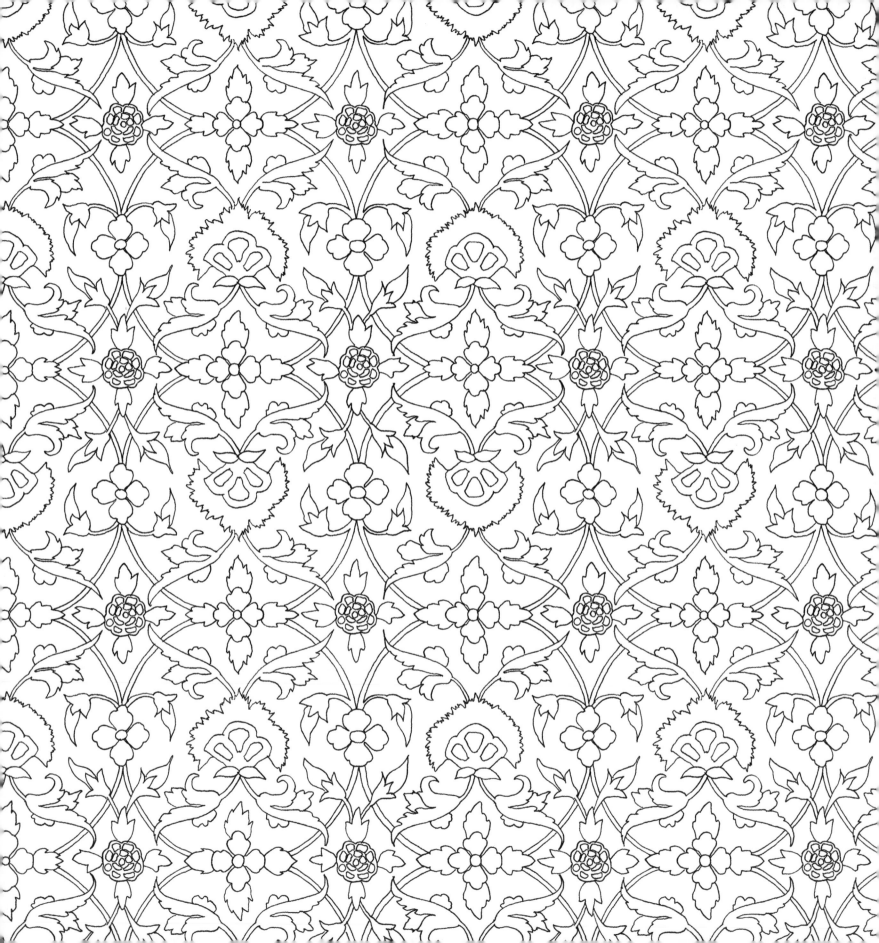

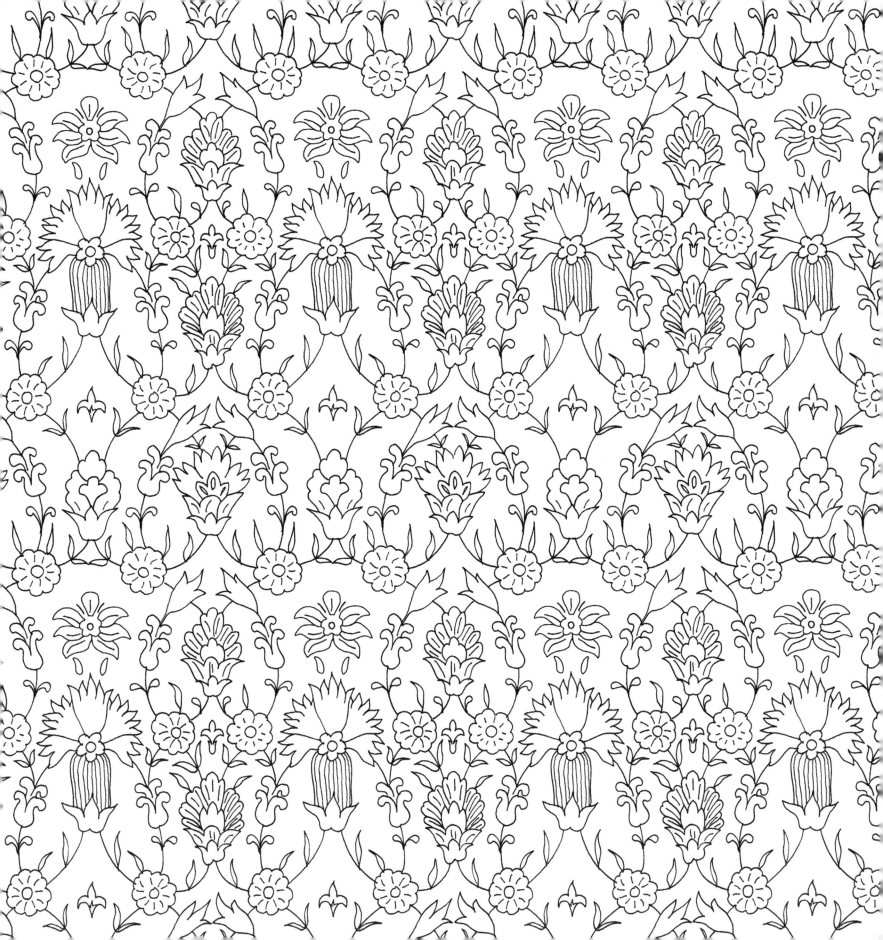

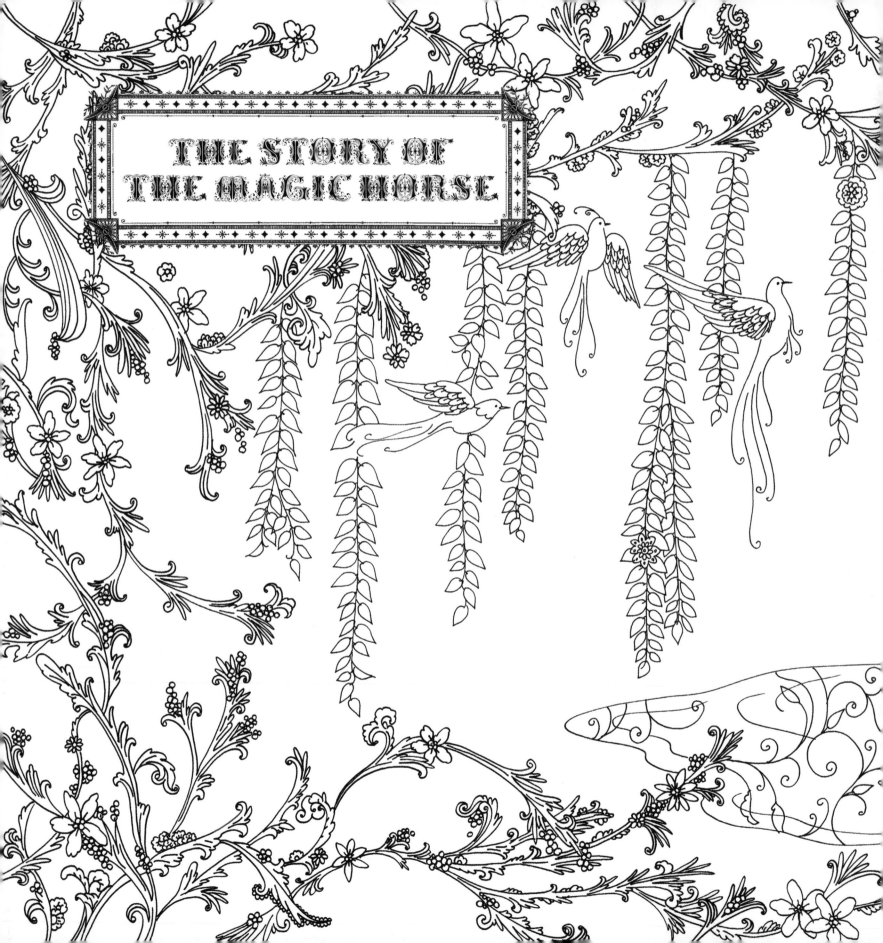

THE STORY OF THE MAGIC HORSE

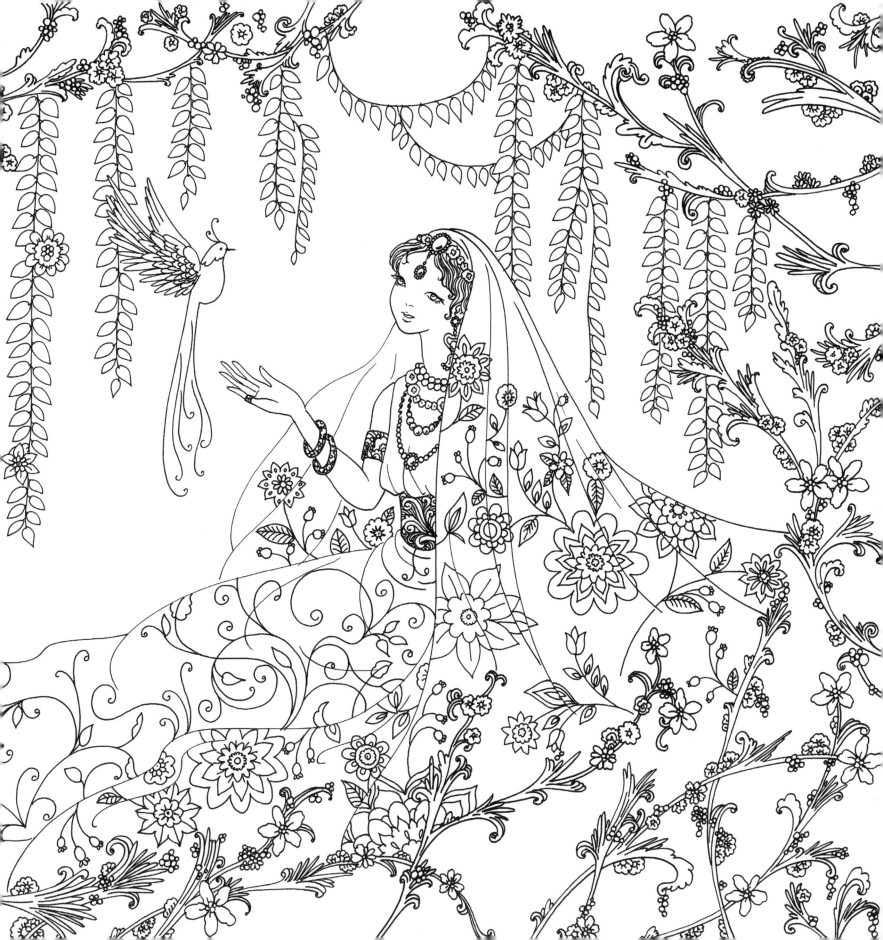

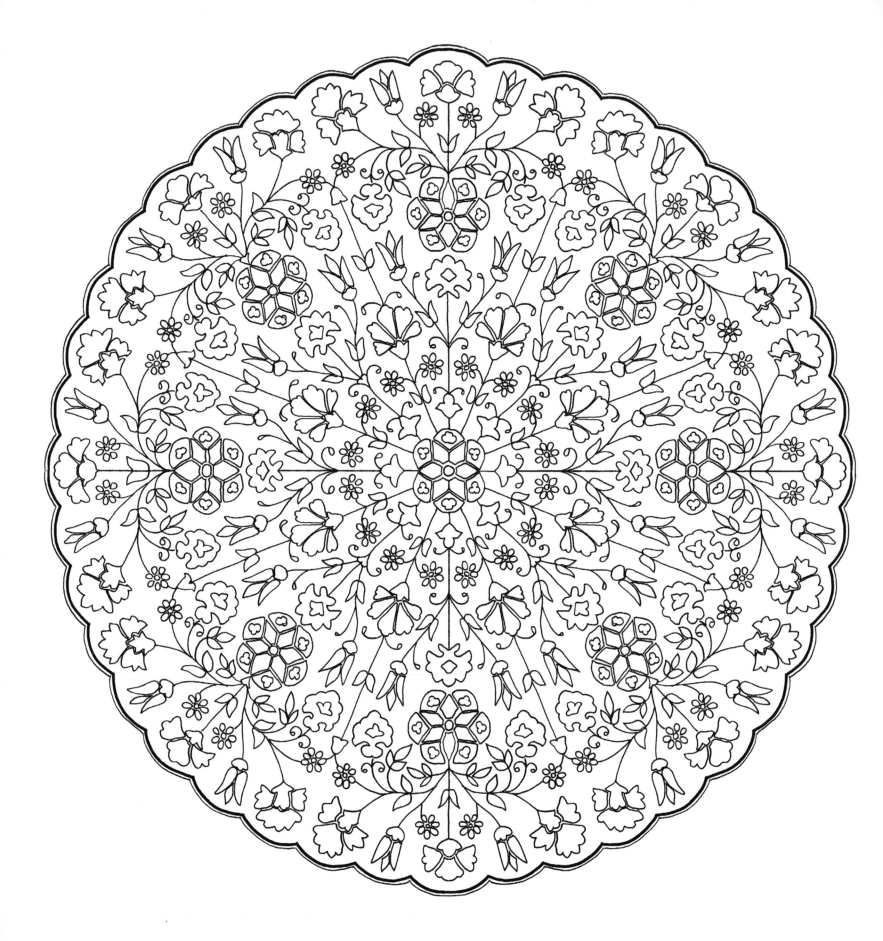

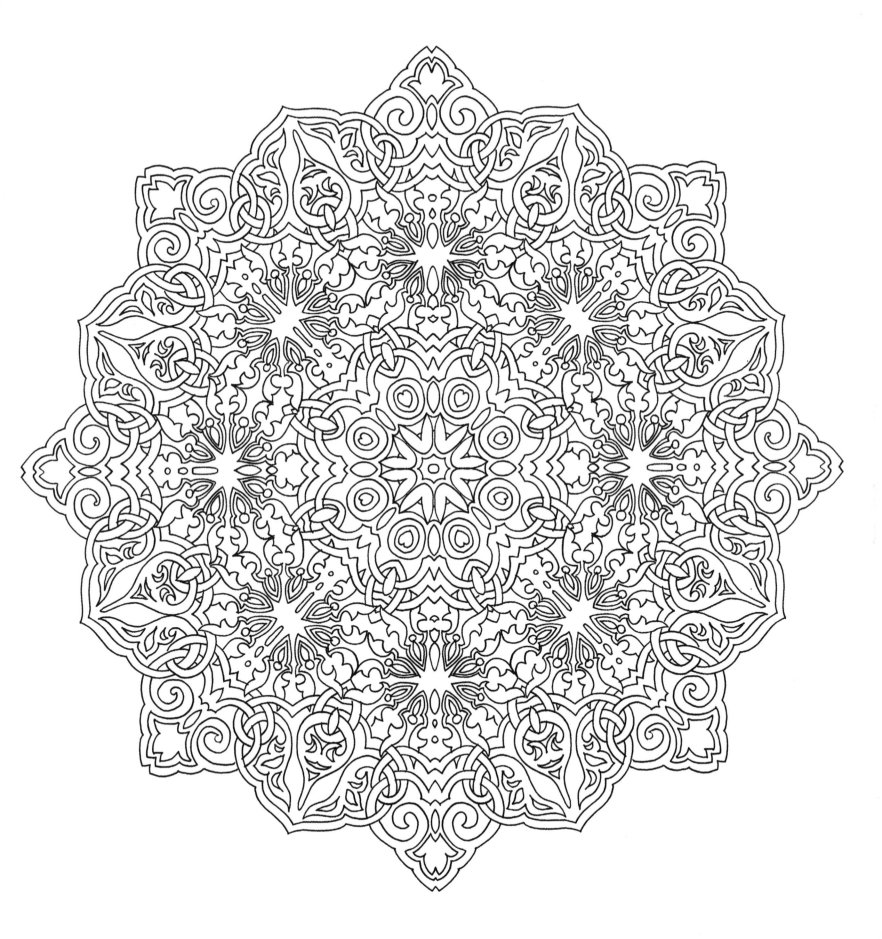

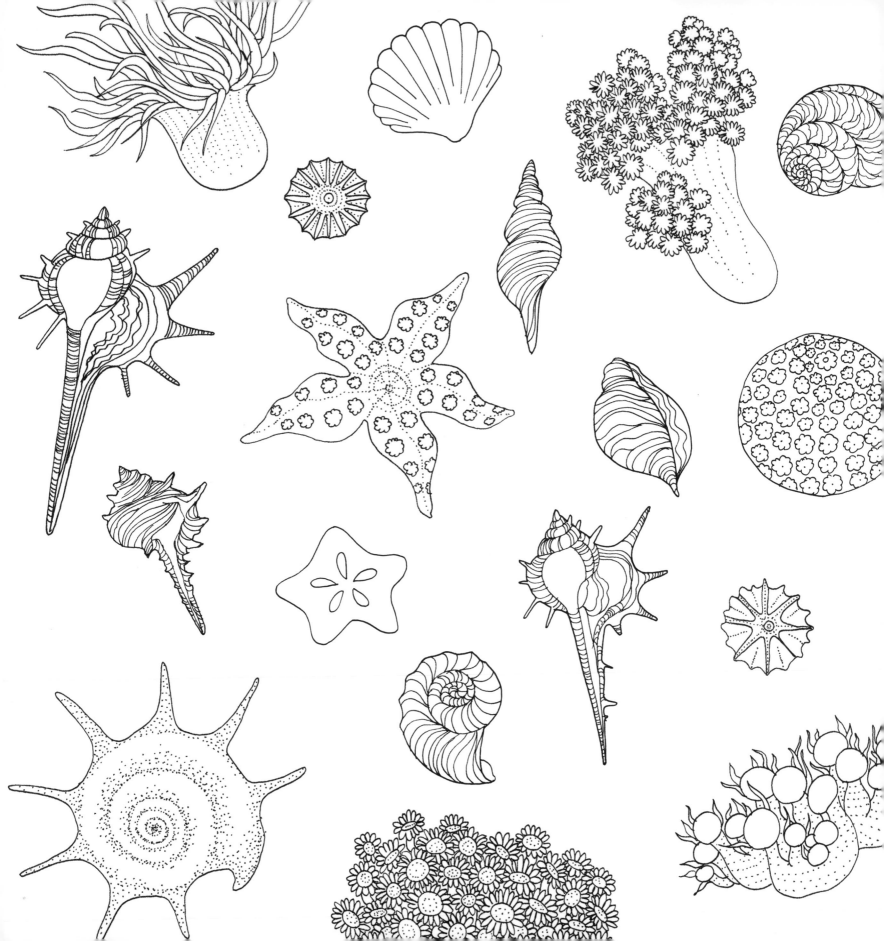

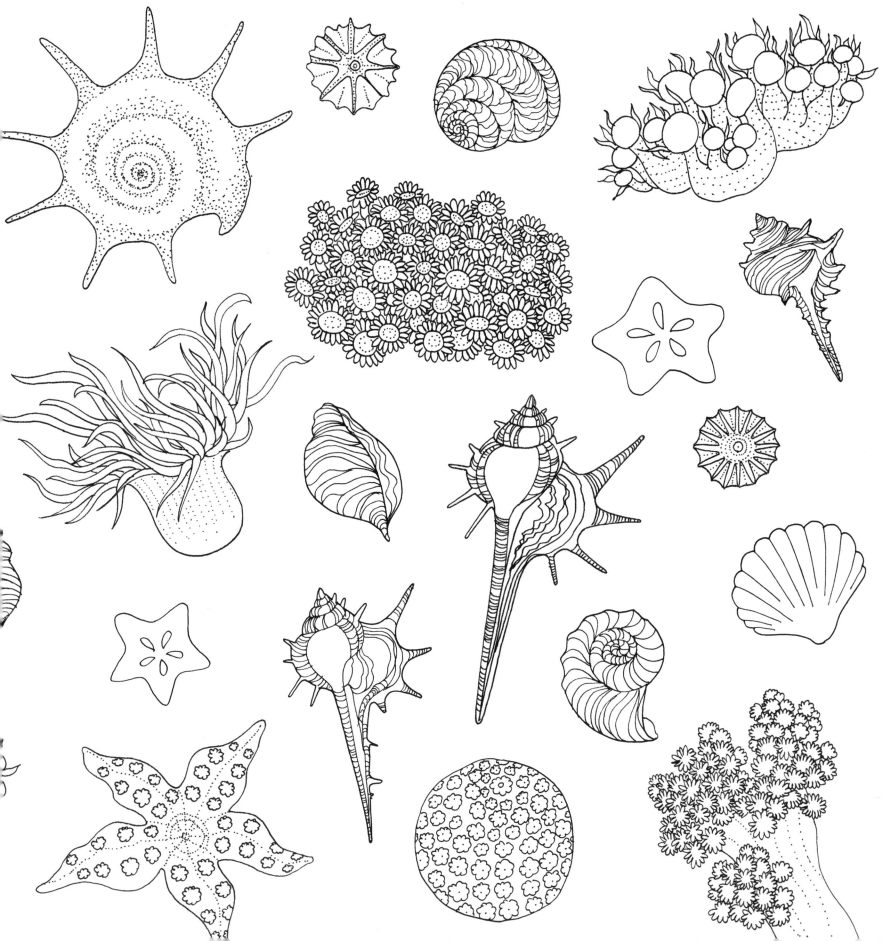

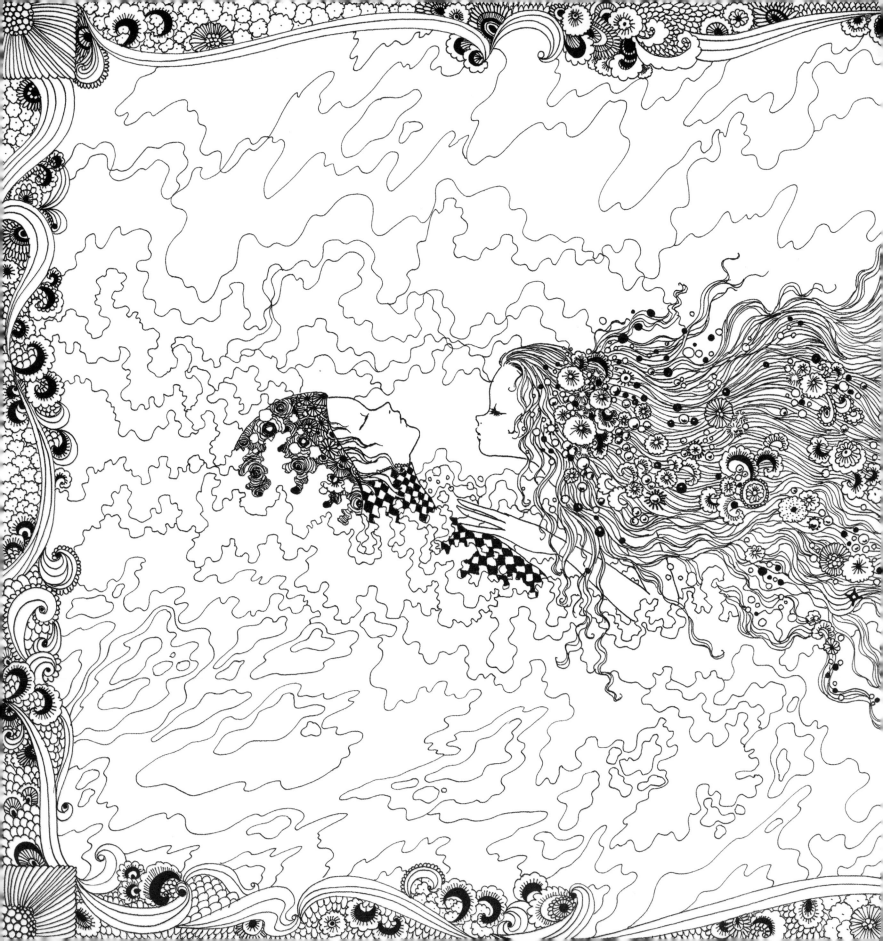

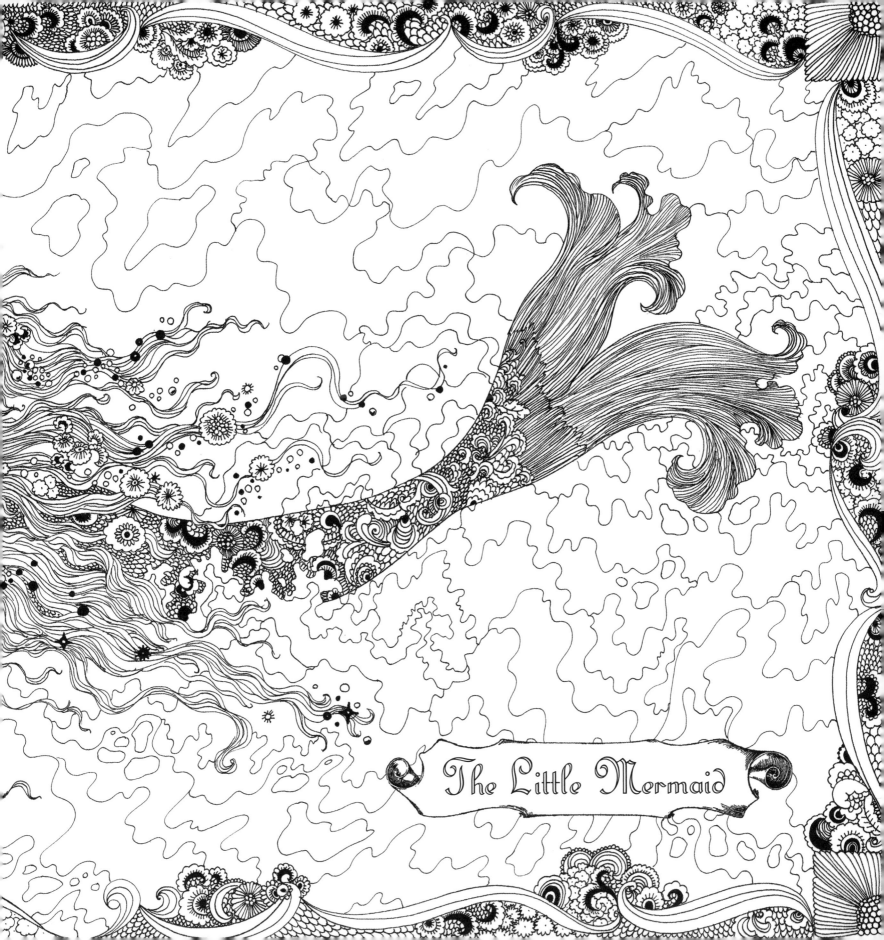

The Little Mermaid

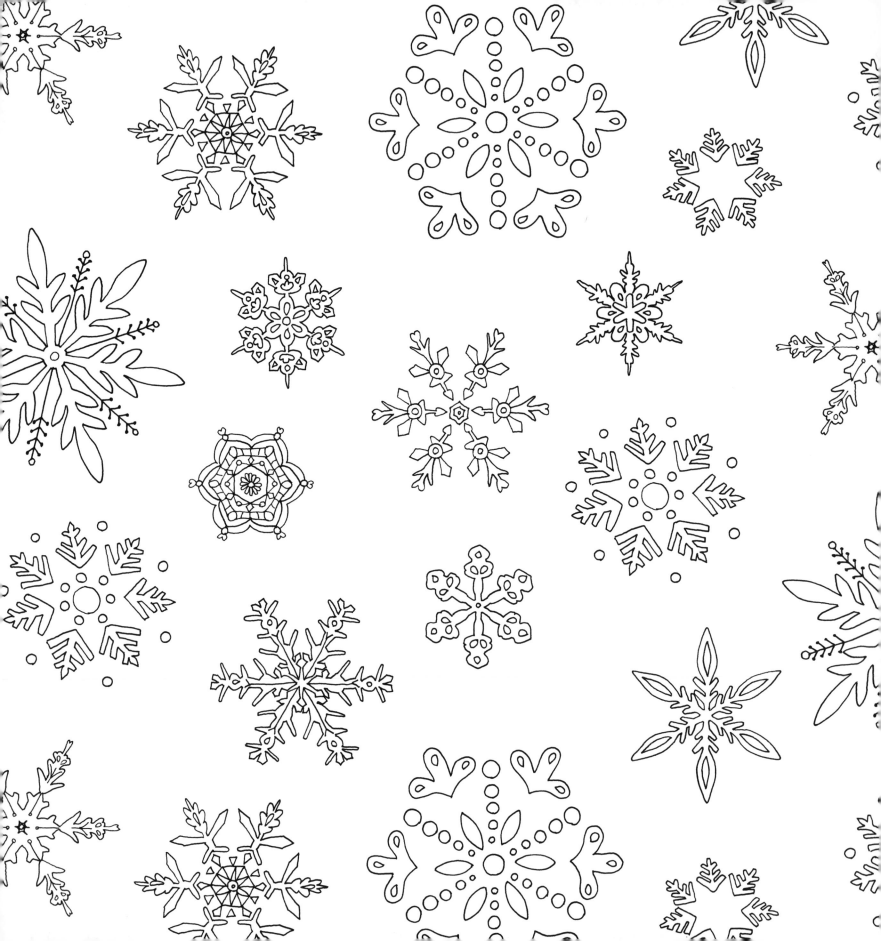

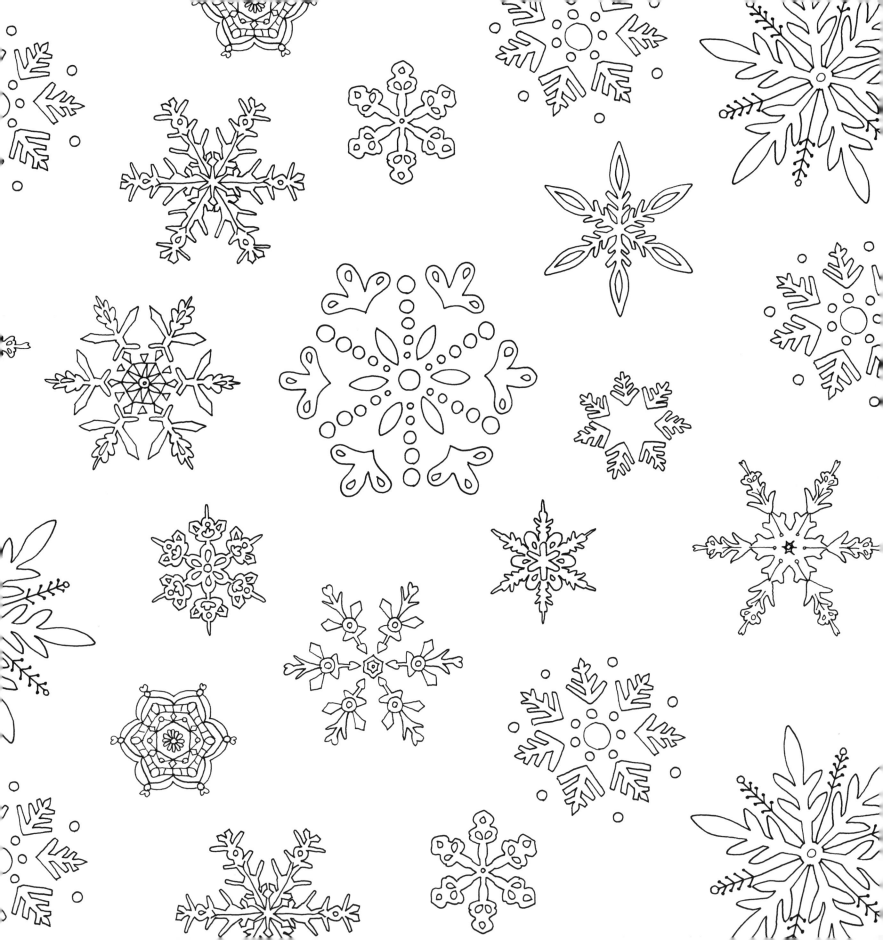

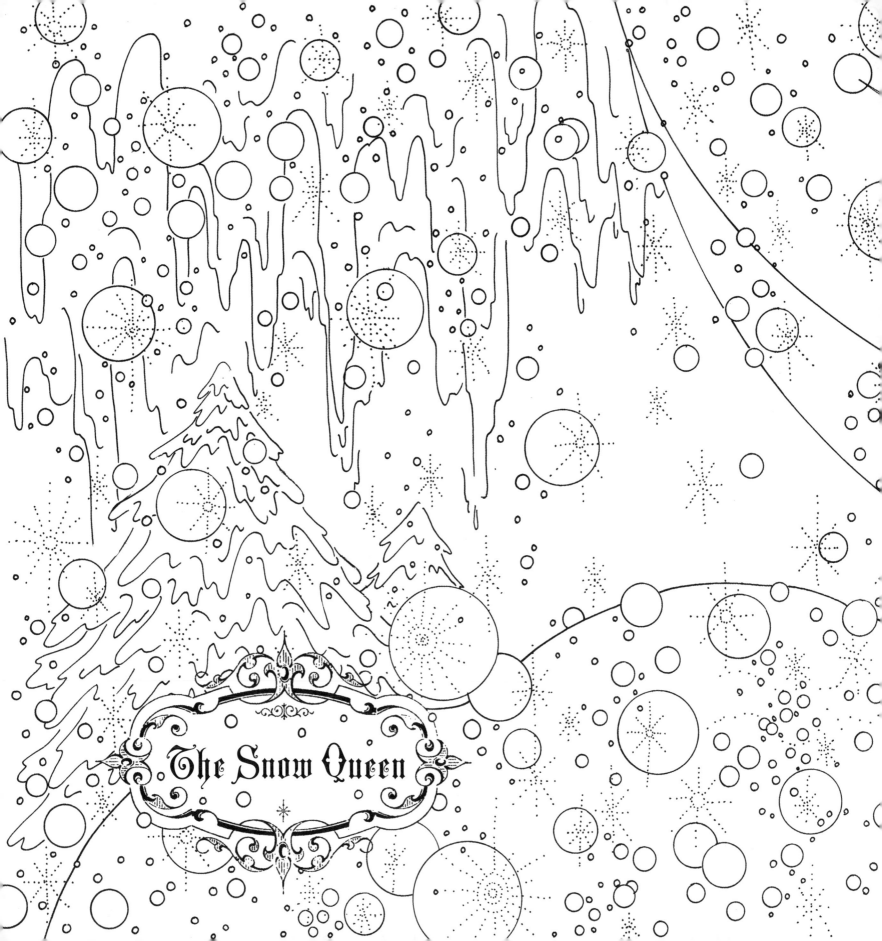

The Snow Queen

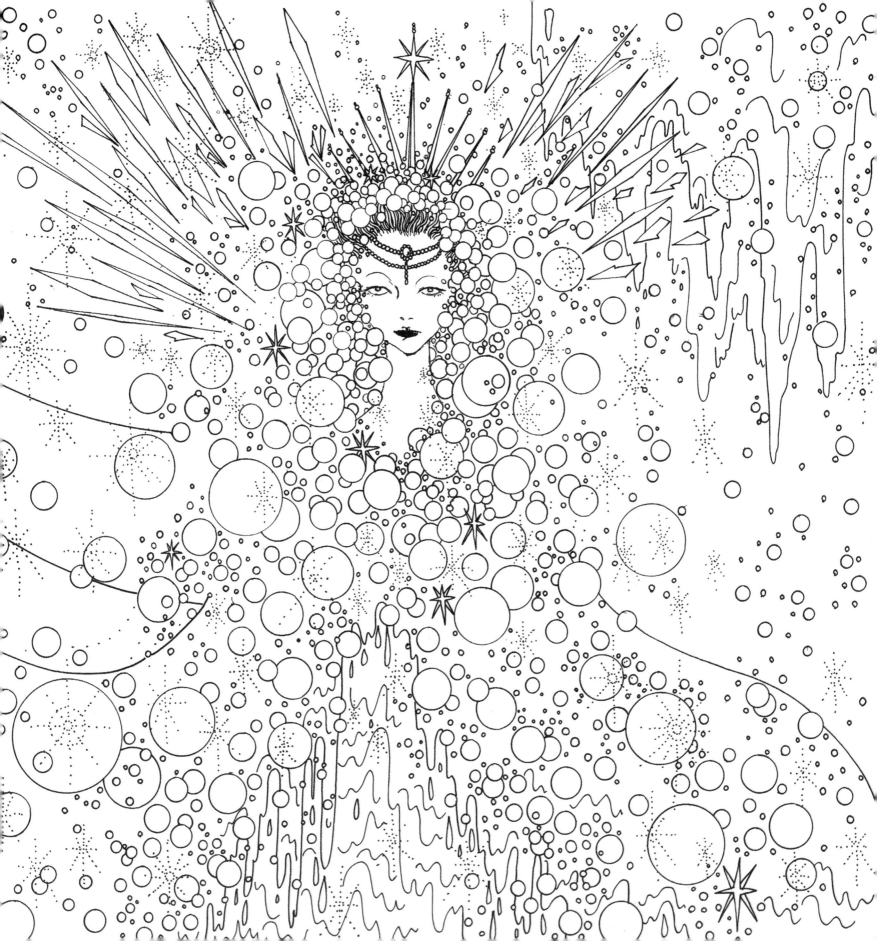

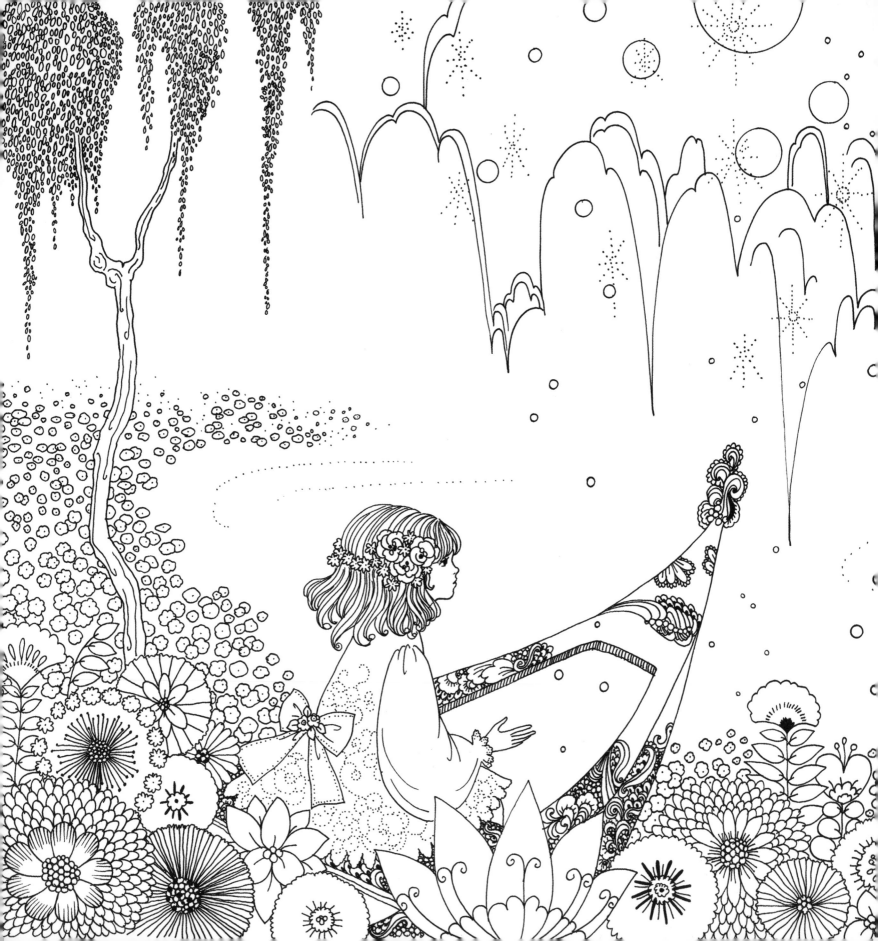

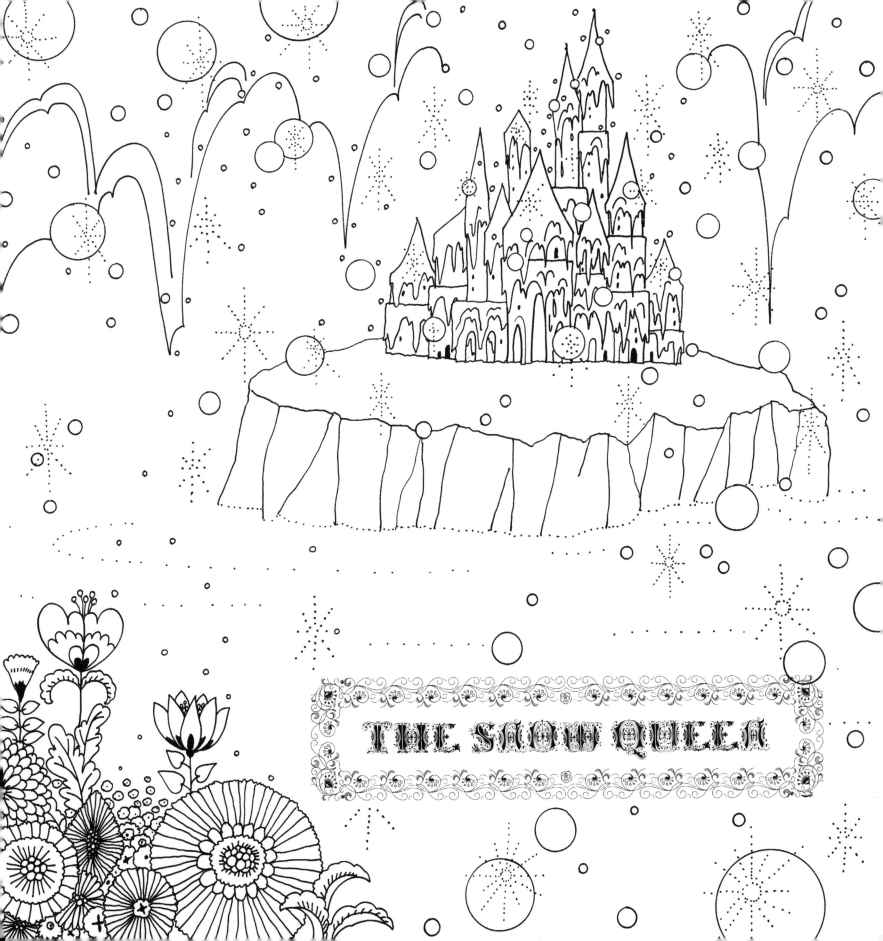

THE SNOW QUEEN

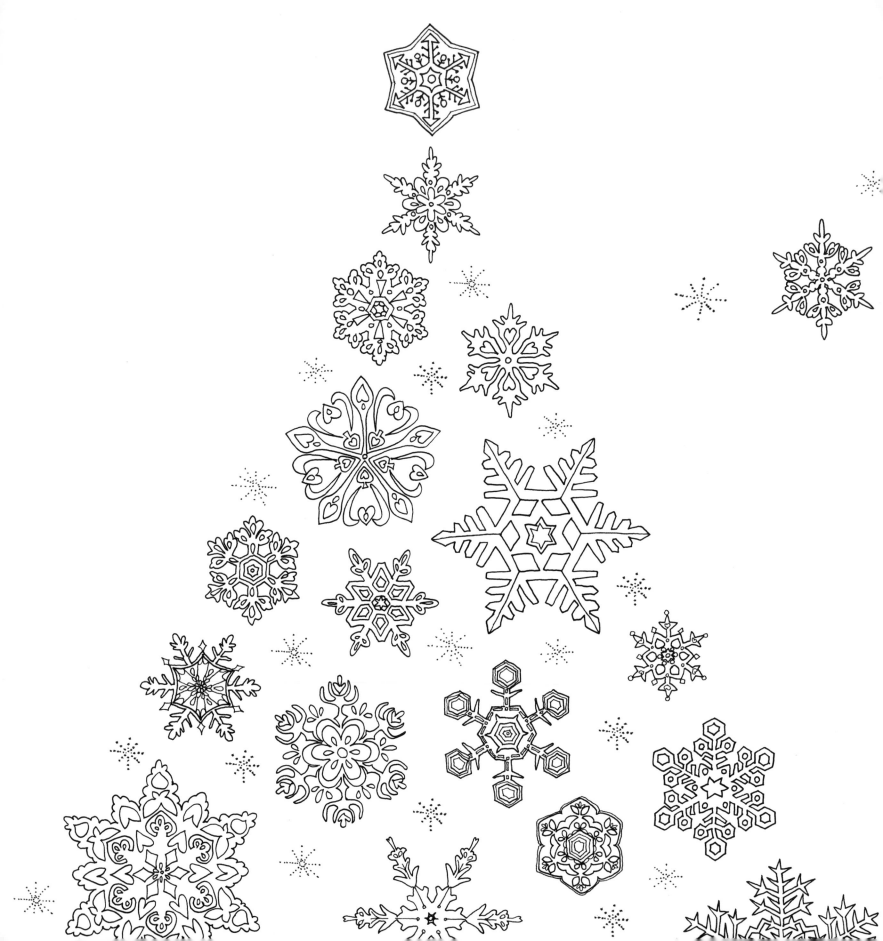

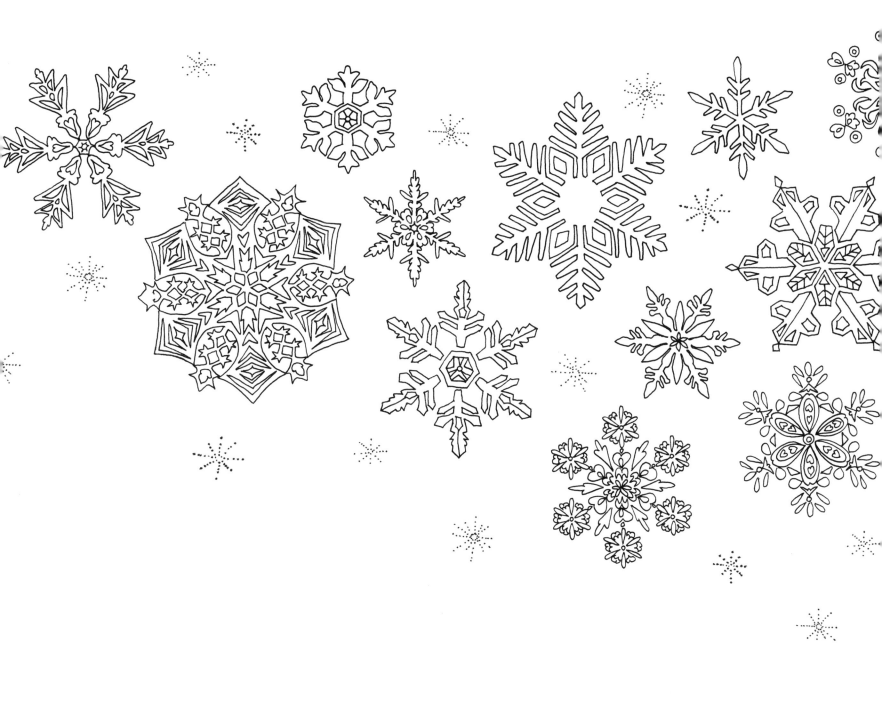

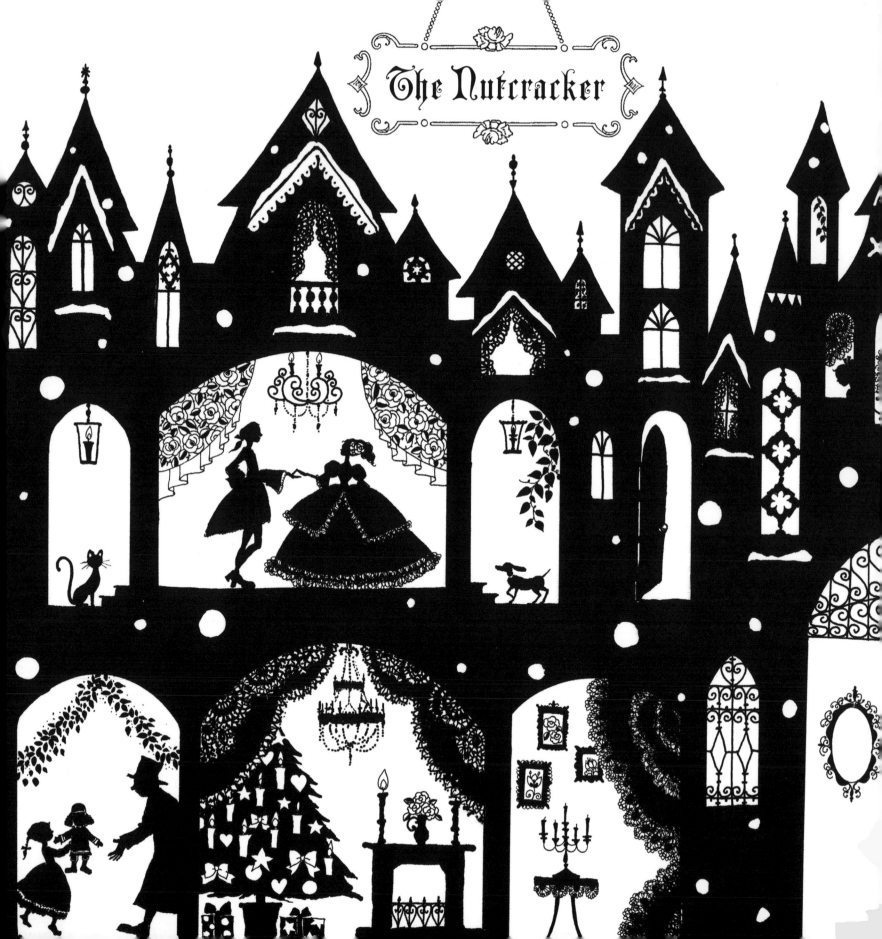

The Nutcracker

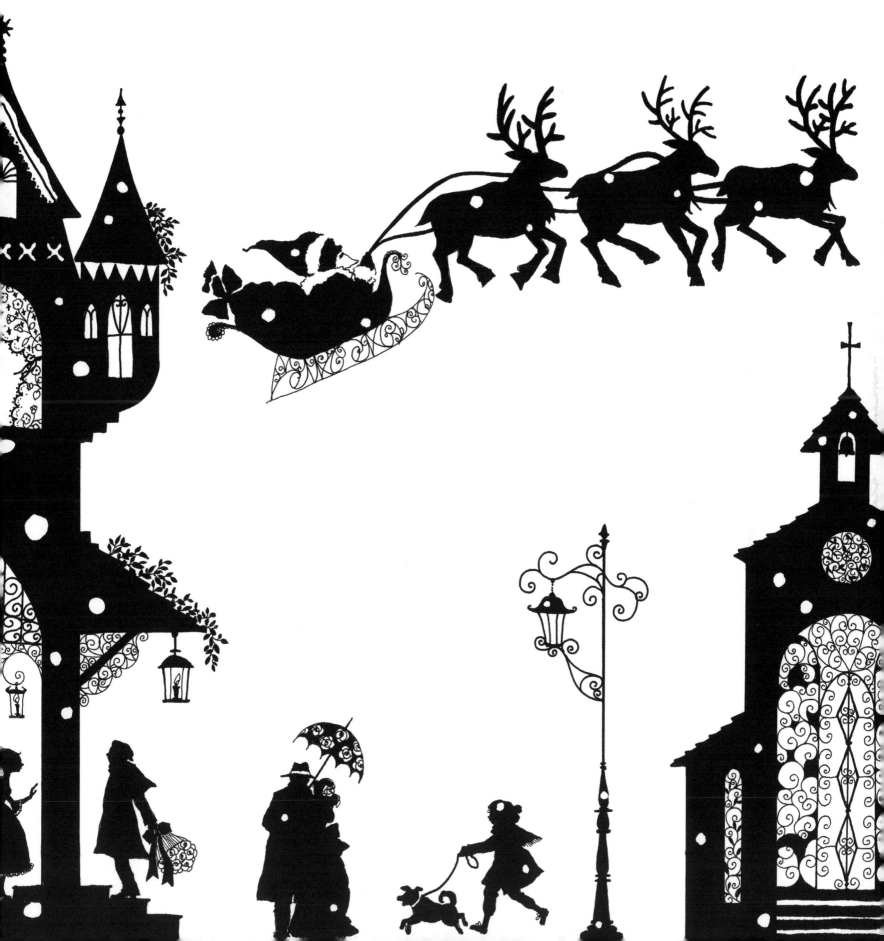

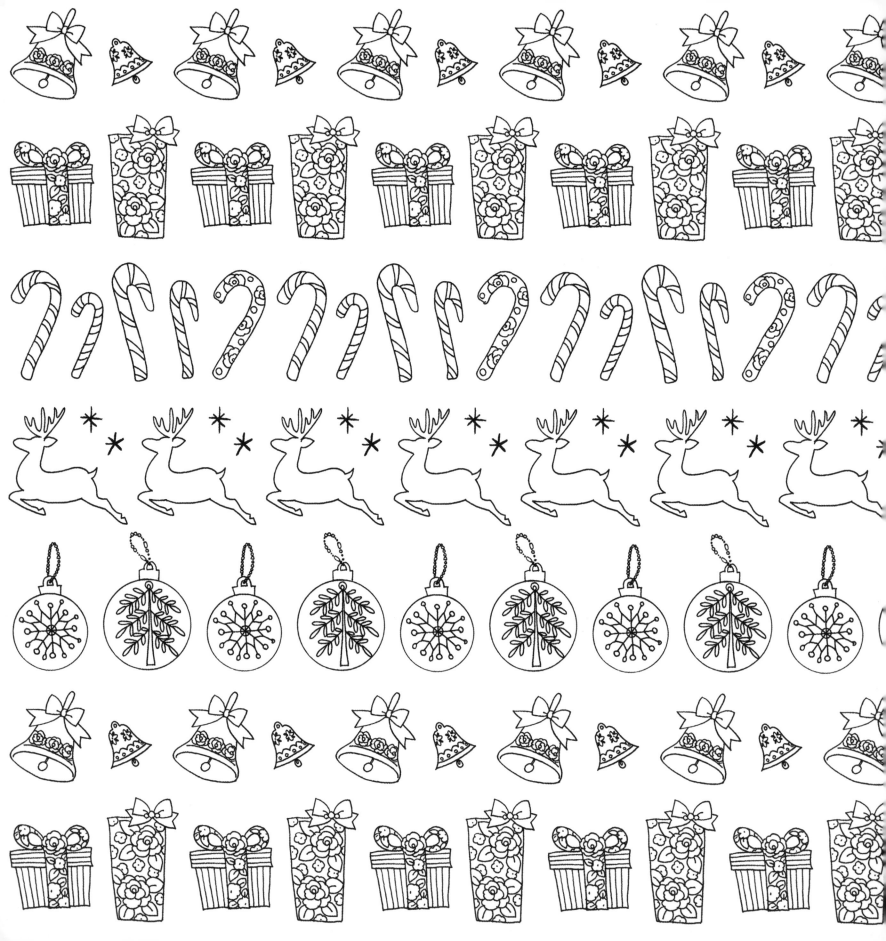

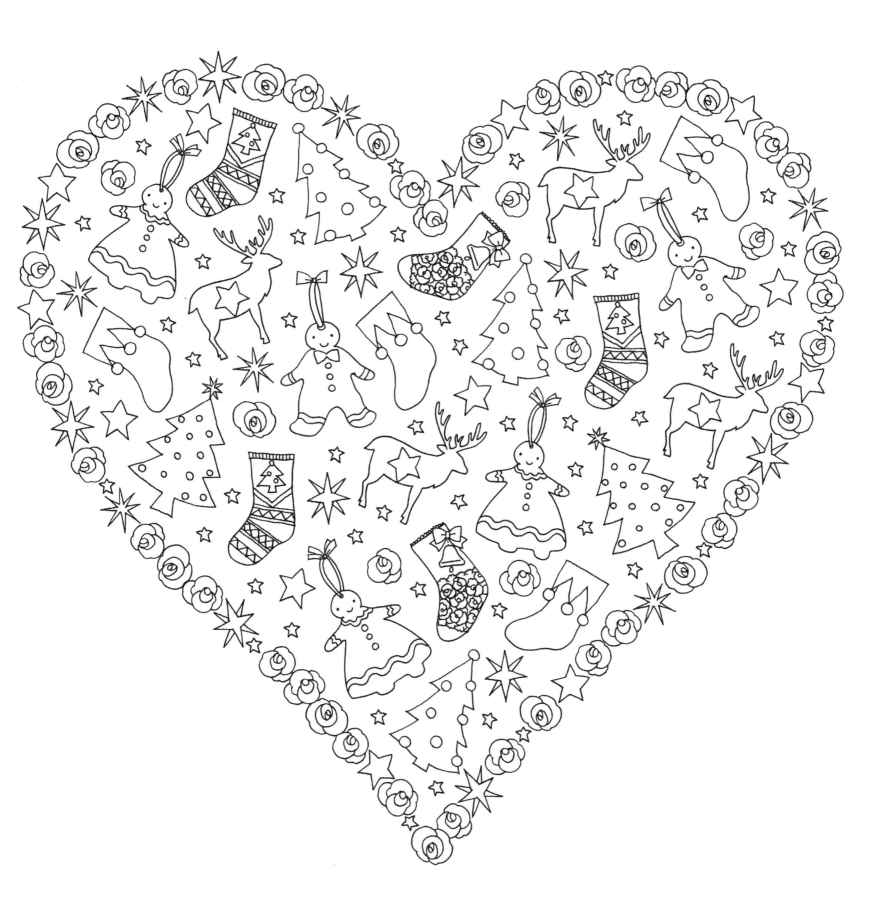

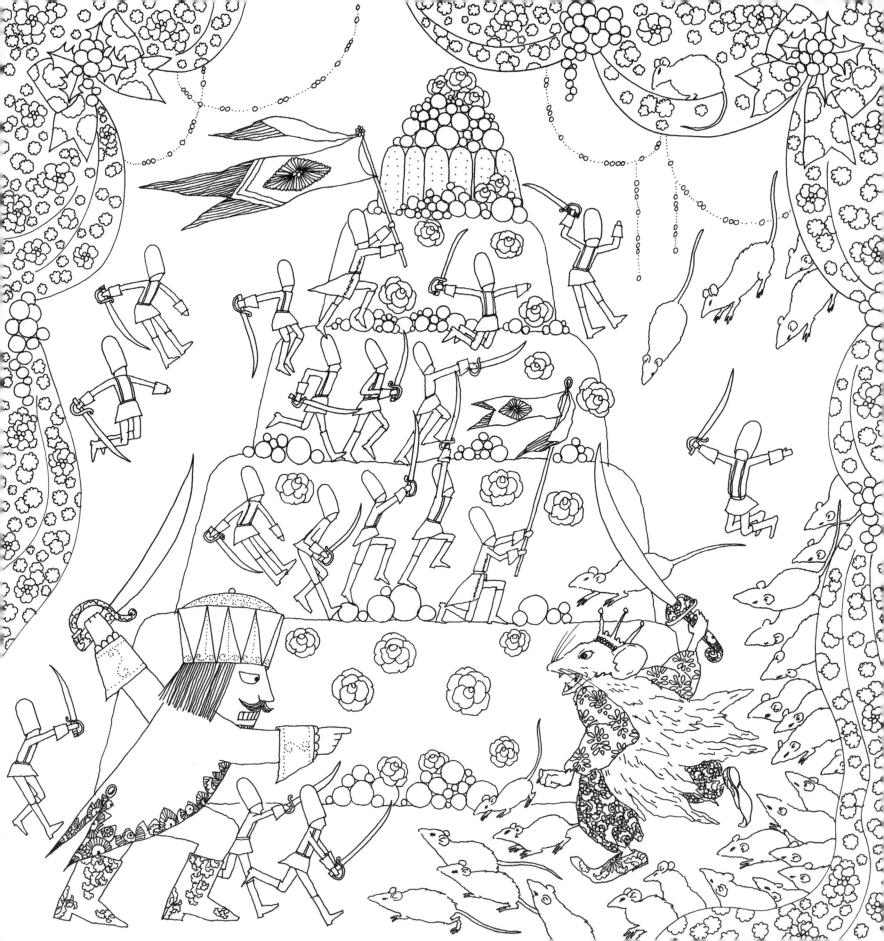

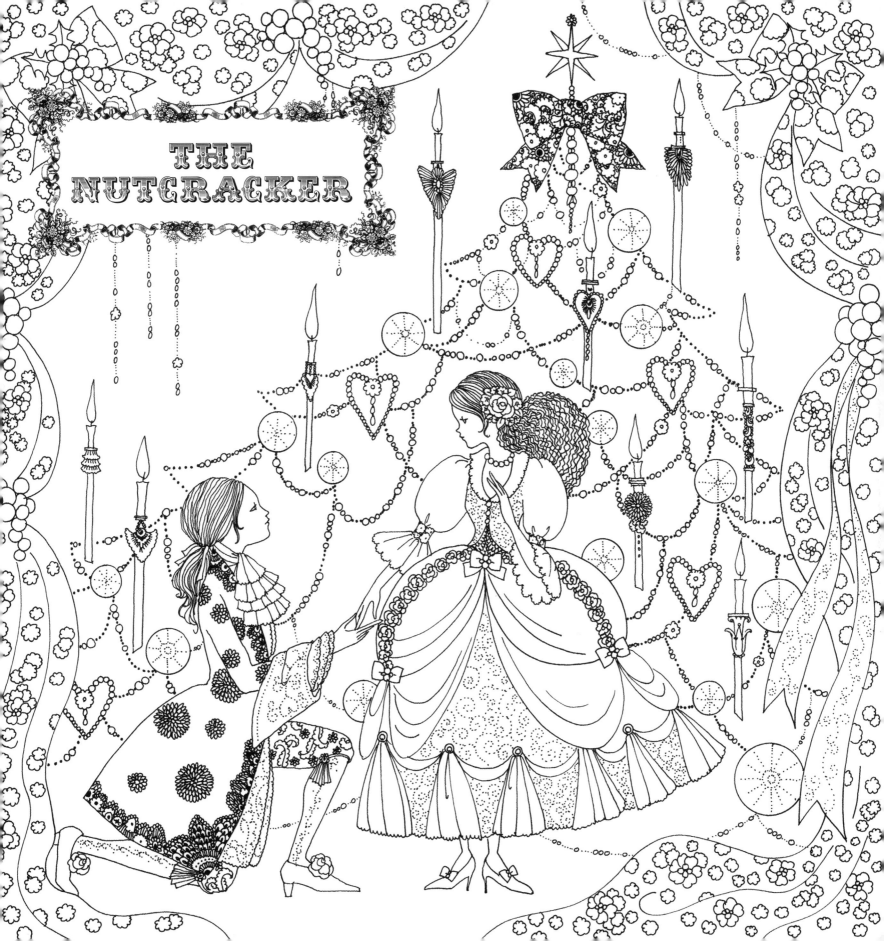

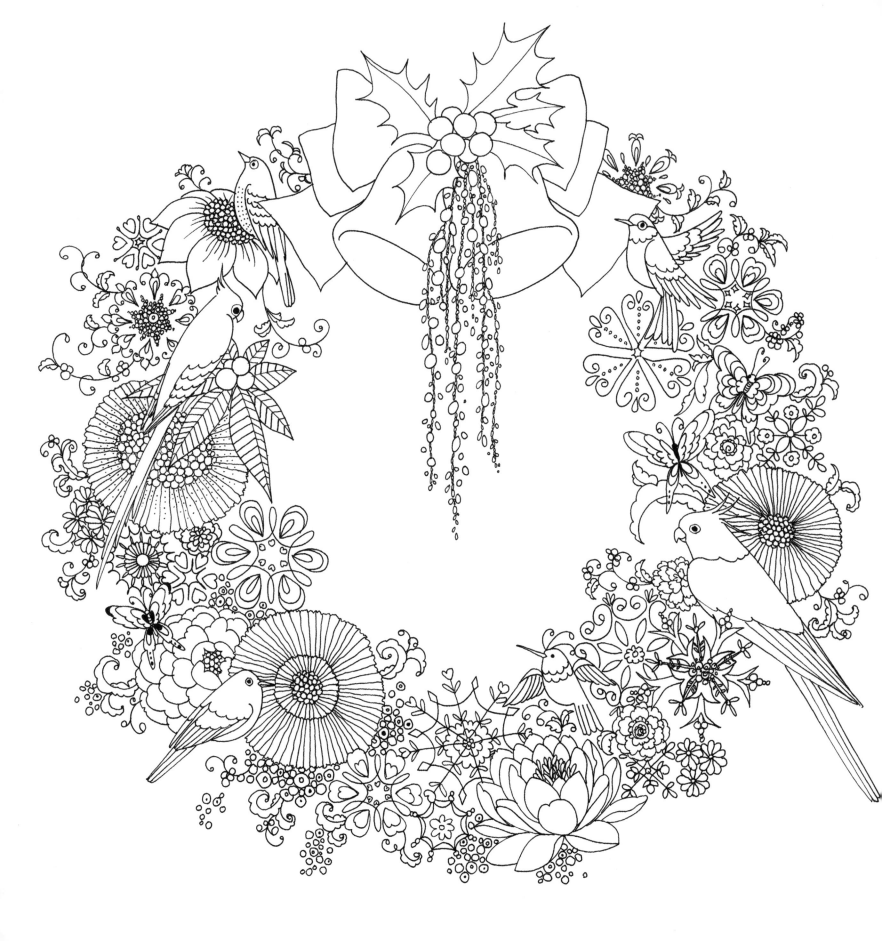

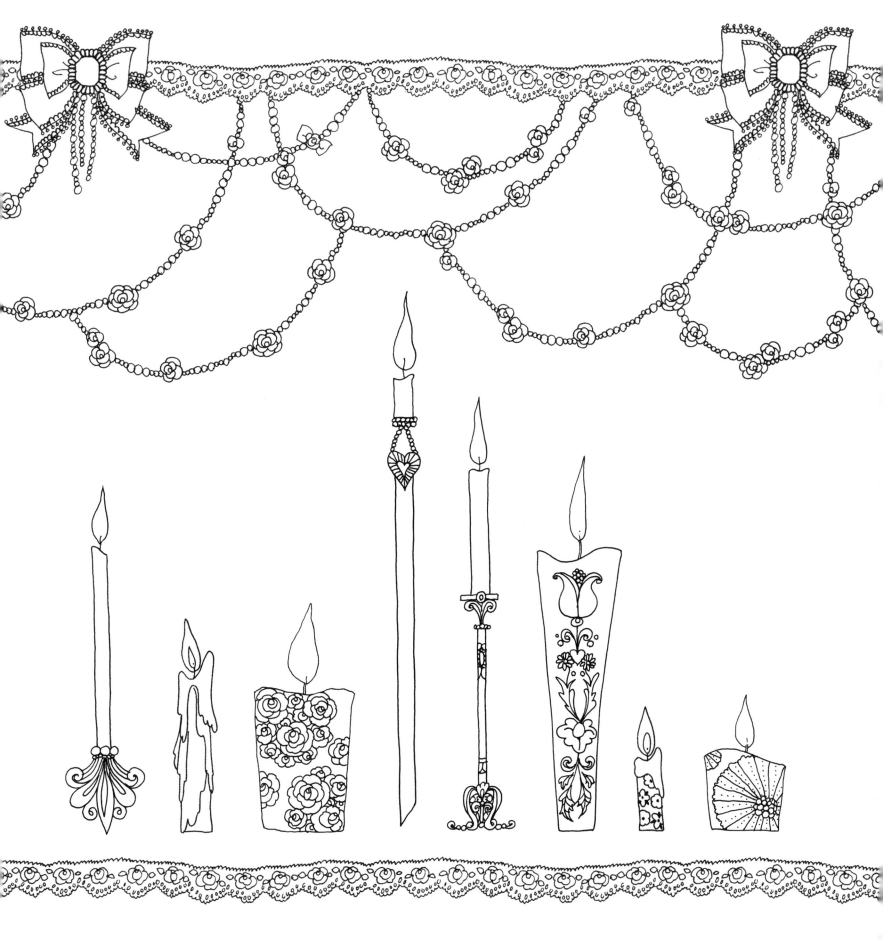

Notes from the author

Born to a father who was an illustrator and a mother who loved to read books, I was raised surrounded by many picture books.

Even now I clearly remember listening to my parents reading to me every day when I was young—classic stories and folk tales from around the world, including stories by Hans Christian Andersen and fairy tales from the Brothers Grimm. A scary witch who casts a spell. A prince who rescues a princess trapped in a castle. A mermaid princess who helps a prince, but then turns into sea foam and disappears because he does not love her in return. The child with ice shards lodged in his heart who was kidnapped by a snow queen.

As a child, I fell deeply in love with the world of picture books. Longing for a beautiful, fluffy dress with fluttering lace, I would wrap the curtains around me like a ball gown or play in my mother's high heels, which were of course far too big for my tiny feet!

But I eventually stopped reading my picture books. What awaited me in my days as a primary school pupil was the golden age of manga comics for girls. The heroines drawn in those comic books were little girls with stars twinkling in their eyes, and the boys they loved were almost like princes who had stepped out of those picture books. I was so engrossed in these comics that it amazed my parents. I would read the comics and then imitate the illustrations by drawing them myself, and then draw and read them all over again. My dream for the future was to become a comic book artist.

Although I didn't become a comic book artist, I did become an illustrator and rediscovered picture books in my thirties. The thing that surprised me when I once again picked up the books I had loved as a child was the beauty of the illustrations, their strength and delicacy, and the skill with which they were drawn. I wanted to draw pictures like this and create these types of illustrations myself. This coloring book is based on that wish.

Princes and princesses falling in love. Full, flowing dresses. Floral headpieces. This book is filled with all those who dwell in the world of dreams.

When I add colors to the lines I've made with a pen, my mind gradually becomes clear and it feels as if I'm meditating or chanting a mantra. Use your favorite colors with a quiet, relaxed mind. There are no rules or laws about the way to color. Set yourself free.

It is you who gives color to this world drawn in black and white. With your heart as your guide, use your favorite colors wherever you like, and just color, color, color!

When you've finished coloring, your very own world will be spread out before you. Create a book that's one of a kind. I hope you enjoy it to your heart's content.

Afterword

When I was a child, I dreamed of the worlds drawn in picture books.

As a primary school pupil, my friends and I drew the heroes and heroines of our comic books on our desks at recess, on our textbooks, on the corners of our notebooks, on the top margins of our papers and canvases.

And now that I've grown up, I'm still drawing fairy tale kingdoms. I draw them anytime, anywhere.

I've filled this book with ideas from the picture books and comics that I loved when I was younger. My hope is that you use your heart as your guide as you color in the pages.

Also, I hope that your imagination will be expanded by the fairy tale kingdoms you yourself have created as you color in the lines, and that you will explore and play in those kingdoms to your heart's content. Finally, I would like to thank my editor, who truly understood my idea, and the designer who took my imaginary world of illusions and turned it into a beautiful book. Thank you.

LARK
New York

An Imprint of Sterling Publishing Co., Inc.
1166 Avenue of the Americas
New York, NY 10036

LARK CRAFTS and the distinctive Lark logo are registered trademarks of Sterling Publishing Co., Inc.

This Lark Crafts edition published in 2016
First published in Japan by PIE International in 2015

© 2015 by Tomoko Tashiro / PIE International

ISBN 978-1-4547-1000-4

Distributed in Canada by Sterling Publishing Co., Inc.
c/o Canadian Manda Group, 664 Annette Street
Toronto, Ontario, Canada M6S 2C8

For information about custom editions, special sales, and premium and corporate purchases, please contact Sterling Special Sales at 800-805-5489 or specialsales@sterlingpublishing.com.

Manufactured in Singapore

2 4 6 8 10 9 7 5 3 1

www.sterlingpublishing.com
www.larkcrafts.com

Tomoko Tashiro

Artist and illustrator Tomoko Tashiro was born in Tokyo, Japan. She graduated from Tama Art University, Department of Painting, with a major in Japanese painting studying under Fumiko Hori. Tashiro has been actively involved in a wide range of projects, including book cover designs, illustrations, magazine advertisements, department store window displays for Shinjuku Isetan and Shinjuku Odakyu Ace, as well as package illustrations for the cosmetics companies Kose and Shiseido.